P9-CBP-360

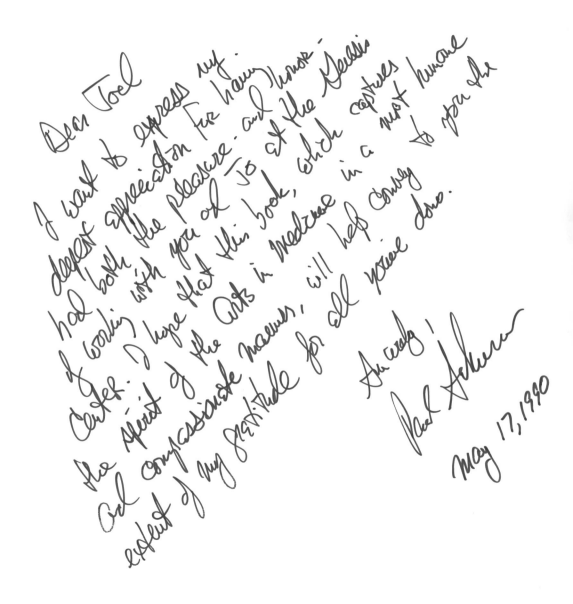

Dear Joel

I want to express my
deepest appreciation for having
had both the pleasure and honor
of working with you on Jo at the Genesis
Center. I hope that this book, which captures
the spirit of the Arts in Medicine in a most humane
and compassionate manner, will help convey to you the
extent of my gratitude for all you've done.

Sincerely,
Paul Ashurer

May 17, 1990

Copyright © 1989 G. B. Lippincott
ISBN 0-397-58314-1
Library of Congress Catalog Card Number 89-84532
Fifth edition (Revised), 1989

All Rights Reserved. No part of this book may be reproduced in
any form without permission from the publisher.

Printed in Sweden by Bohusläningens Boktryckeri AB, Uddevalla 1989
Published by the G. B. Lippincott Company, East Washington
Square, Phila., Pa. 19106.

Creativity and Disease

How illness affects literature, art and music

Philip Sandblom, M.D., Ph.D. h.c.

G. B. LIPPINCOTT COMPANY, PHILADELPHIA

In great artists, the desire to create and the endeavour to immortalize a personal conception may overcome even extreme disability. Thus, despite painful old-age arthritis which obliged the artist to have cotton taped to the palm of his hand so as to be able to hold the brush between the thumb and the ring-finger, as we see in the self-portrait, Renoir painted pictures that radiate youthful joy, and took delight in representing children, young women and the flowers of spring. Matisse was witness[40]: *"A lengthy martyrdom—his finger-joints were swollen and horribly distorted—yet he now painted his best works! While his body wasted away, his soul seemed to gain strength and he expressed himself with increasing ease."*

For Grace

A Being breathing thoughtful breath,
A Traveller between life and death;
The reason firm, the temperate will,
Endurance, foresight, strength, and skill;
A perfect Woman, nobly planned,
To warm, to comfort, and command;
And yet a Spirit still, and bright
With something of angelic light[98]

Contents

Forewords

The treatise by my admired friend Philip Sandblom on "Creativity and Disease", for which I have been asked to write a short preface, testifies to the advantage of an interdisciplinary approach to a humanistic theme that could not be adequately studied from one side only. The author carries the ideal prerequisites for such an approach by being at the same time an internationally renowned surgeon and a life-long lover of art for art's own sake.

Sandblom's double competence as a physician and an art connoisseur—both activities for which the eye is the supreme tool—asserts itself on every page of this book. It is indeed fascinating to follow under his guidance the mysterious links, sometimes for better, sometimes for worse, that exist between illness and creativity, in the past as well as in present time, in literature and music, as well as in art.

The richness of the theme, which in an almost kaleidoscopic fashion assumes ever new patterns, will, I am confident, appeal to both medical and humanistic readers. In fact, one of the merits of this book is that the author has been able to treat his subject both with serious understanding and with something of the liveliness of an informal talk. It is clearly by an author who has read much, seen much, heard much and thought much about the whole issue. Happily free from sentimentality, he invites us to share with him a deeper insight into many of art history's most poignant lifestories. Once you start reading, you will not easily put the book aside before having finished it.

Carl Nordenfalk, Ph.D.
Director emeritus of the Swedish National Museum

As gene splicing, molecular biology, automated clinical chemistry and CAT scanning gradually seem to be replacing artful physicians with glorified technicians, it is gratifying indeed to read a book by a cultured and sensitive physician whose concern is the interaction of soma and soul. Sandblom gives us a finely crafted historical survey of instances where illness affected creation.

To any cultured physician the psychopathology of expression is an intellectual challenge as much as it is a puzzle to creative artists themselves and to laymen who know and enjoy art. Works of art, written, visual or tonal, elicit in the beholder physical phenomena and psychic responses, akin to those that may have stirred their creators while producing the art.

Some day a smart young biochemist, who may or may not be a physician in the humanistic sense of the word, may clear up the mystery of how soma and psyche interact to produce or to react to works of art. He may find that this involves endorphins or other, as yet unnamed messengers within the body which interact with specific receptors after activation by complex hormonal and enzymatic mechanisms.

Such an investigator (if at his time people will still be able to read) may well have been inspired by Sandblom's overview of the interaction of illness and creation. Such is the hypothetical impact of this book on future medicine. For the present, it is certain that this articulate and erudite study by a cultured physician will give great pleasure and stimulation to all who appreciate and love art.

Freddy Homburger, M.D.
Research Professor of Pathology, Boston University School of Medicine

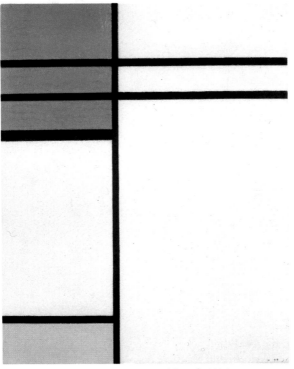

1. P. Mondrian, Composition with red, 1936.

Mondrian affirms his credo[56]*: "It is the line, the color and their relations which must bring into play the whole sensual and intellectual register of the inner life."*
Discussing this Composition with red, 1936, *Butor*[14] *assures us that "Mondrian is clearly aware of the tragic character that a cross inside his composition can present", and he ventures to suggest that "this small red spot represents the fatal twilight with the sun setting tragically".*

Introduction

Per varios usus artem experientia fecit. (Manilius I, 59)
Through varied trials experience creates art.

"For most poets, poetry is but a current commentary on their private lives, a transcription into verse of the prose of their Fate." The author[81] who voiced this idea might well have extended it to the artist in general, because art is always founded on experience; one cannot create from nothing.

This truism must still seem meaningful since it is so often repeated and elaborated upon. Anton Chekhov modestly admitted that "if I had only my imagination to rely on in attempting a career in literature, I should like to be excused"; as it was, his experience included a medical education as well as his own tuberculosis. Henri Matisse[55] explains how "the artist works by incorporating and gradually assimilating the exterior world until the object which he designs has become as it were a part of himself —and he can project it on the canvas as his own creation". Gustav Mahler[53] accepted the idea with these words: "creative art and actual experience are one and the same" but also indicated a modification, as one senses in his music: "a bit of mystery always remains, for the creator as well." Still he tries to clarify the mystery, as far as words can help, by describing it as "the steady intensification of feeling, from the indistinct, unbending elemental existence (of the forces of nature) to the tender formation of the human heart, which in turn points towards and reaches a region beyond itself".

When considering different aspects of the conception

to test its validity, one stumbles on abstract art—can that be founded on anything but sheer invention? It is a relief to find that Mondrian, one of the great protagonists, was eager to answer the question.[56] He says explicitly that "all that the nonfigurative artist receives from the outside is not only useful but indispensable, because it arouses in him the desire to create that which he only vaguely feels and which he could never represent in a true manner without the contact with visible reality and with the world which surrounds him" (Fig. 1).

The connection between art and experience is more convincing in realistic painting and may even be pathetically evident as in the case of Frida Kahlo, the Mexican surrealistic painter, wife of Diego Rivera. "I paint my own reality" she said, and a tearful, bleeding and painful reality it was. Her claim to a record number of operations was hardly an exaggeration—she underwent thirty-two!

A famous American surgeon, Leo Eloesser, who became her doctor and her friend, found that she had an anomaly of the spine, *spina bifida*, causing progressive ulcerations of her legs and feet. As so often among patients with congenital defects, she preferred to blame her condition on some external cause. And well she might, since as a child she had polio, affecting her right leg, and later was badly injured in a traffic accident. Her spine, her pelvis and her foot were crushed, but not her forceful spirit. "I paint because I need to" she explained, describing her suffering in a number of shockingly revealing self portraits. In one (Fig. 2) she is weeping from pain, represented as lacerating nails. The crushed spine on which she blames her misery is depicted as a broken column. But in another painting (Fig. 3), showing her lying in the bathtub, feet sticking out of the water, she gives herself away: the sores between the toes are typical lesions caused by her congenital defect, the *spina bifida*, probably the main cause of her suffering. She thus trans-

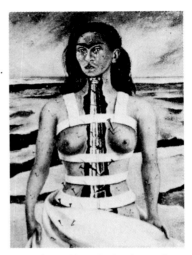

2. Frida Kahlo, The broken column, 1944. One of many self portraits of the artist suffering, her injured spine represented as a broken pillar.

3. Frida Kahlo, What the water gave me, 1938 (detail). The artist in the bathtub; between her toes are the sores that are typical lesions attending the congenital defect of spina bifida. "My foot continues to be sick—'trophic ulcer', what is that?" Even the broken stopper-chain bleeds in sympathy.

muted her pain into art with remarkable frankness, tempered by humor and fantasy[35]. With progressively painful disease she could no longer rely on her work to help master her suffering and she became increasingly dependent on strong painkillers. Under their influence, her personality gradually degenerated, as did her art, with murky colours and messy brushwork. In the end the leg had to be amputated, a terrible blow that is expressed in some pictures of severed legs—"Feet, what do I want them for, when I have wings to fly?"—alluding to her flight from reality and to her imminent flight from life.

Frida is an impressive example of the fact that severe illness exerts a critical influence on our lives, as well as on our creativity. One can accustom oneself to much—but not to pain, especially when it is lingering—as it then is ever before us. Its bearing on the creative work of an artist would be particularly apparent to a physician, with his special knowledge of the nature of disease.

No two people view the surrounding world or a work of art with the same eyes, and our attention will be drawn to features of which we have special knowledge. I suppose, for example, that only a fellow physician can fully appreciate the horror of the poor, incompetent Doctor Bovary (in Flaubert's novel) who had been prevailed upon to try a new method of treating clubfoot (by enclosing the redressed limb in a homemade traction device) and shortly thereafter noticed that the leg became blue and swollen, a dismal foreboding of threatening gangrene. "This made the doctor himself feel sick. He visited frequently to have a look, day or night." We, his colleagues recognize the self-reproach of a physician. "Should the patient die, was he the killer?" The most scrupulous of us would even replace the question-mark with a mark of exclamation! Thus to a large extent our perception of works of art, and for that matter of all that occurs around us, is influenced by our experience and education.

4. A. Strindberg,
Sea-marker in storm, 1892.
The author turned to
painting when he felt that
he had to give free outlet
to his tormented feelings.
At this time he was close to
insanity, wild, but not be-
wildered, as he still mas-
tered his demons, except
those of jealousy, and com-
mented that "few people
are lucky enough to be
capable of madness".

Relationship between illness and creativity

With a medical background and an interest in the arts, my attention was naturally drawn to the diseases of artists. Often I noticed a connection between their suffering and their work. My experience thus differs from that of some authors[28] who belittle the influence of illness on artistic creation, arguing that "it can only be a matter of speculation" and suggesting that everyday incidents and trivialities are equally or more important.

Rather, there are reasons to believe that connections between illness and art are close and common. When a number of tuberculous patients were encouraged to use painting as a means of occupational therapy,[48] it was found that the course of the illness was recorded with extraordinary accuracy in the individual's paintings: "The apprehension and despondency prior to haemoptysis or surgery, the sadness and apathy which follow such an event, the freshness and gaiety during convalescence—all are registered on the patient's pictures like entries in a diary."

A study of the relationship between the suffering and the works of artists who have been severely ill may enhance our understanding of their art.[95] I cannot agree with those critics who proclaim that it is only the work itself which is worthy of serious interest and that the personal background of the creators is little more than anecdotal. Few have tried, and still fewer have succeeded in following Flaubert's dictum that "An author in his book must be like God in the universe, present everywhere and visible nowhere... the artist must make

posterity believe he never existed". His declaration, "Madame Bovary, that is me", only intensifies our curiosity about his personality.

Among different kinds of art there is a close relationship in terms of form as well as content, and they often develop side by side; this is hardly surprising since they are closely linked with the general pattern of cultural evolution. But the development is not exactly parallel. At one time the formative arts tend to be closer to literature, sometimes even to the political pamphlet, at another time closer to music, with its abstract form.

Many great spirits rank music highest in the hierarchy of expressive power, in the capacity to make the soul tremble with emotion. Carlyle calls music "the speech of angels" and although not exactly an angel, Napoleon felt that "of all the arts it is music that makes the deepest impression on the soul", bearing out that "the bravest are the tenderest". Music also possesses a capacity for appeasing uneasy minds, dispelling the "spirit of Saul", or in the words of the 18th century playwright Congreve, "music hath charms to soothe the savage breast". But it may also excite, and the effect can be measured in changes of pulse rate and blood pressure. This may have striking consequences: no less than three orchestral leaders are said to have collapsed over a particular passage in Wagner's Tristan![22]

How about literature and art? Are there similar examples of a physical effect of their creations? Literature hardly—no reader has been known to faint in his chair from ecstasy over a beautiful passage; and if, in a more comparable situation, an actor suddenly interrupts his monologue he is more likely to have forgotten his lines than to have been emotionally overwhelmed by the beauty of Shakespeare's verse.

In this respect art is a step ahead of literature. On the lowest level, pornography, simple souls, to judge

from the market, derive more satisfaction from obscene pictures than from written descriptions of erotic episodes. On the highest level, divine art has elicited testimony of a power that equals that of music; the resulting medical condition has been given a special term, the *Stendhal syndrome*. This is a kind of collapse which struck the French author on his Italian voyage. He relates about a day in Florence; "The Sibyls of Volterrano gave me the most precious delight I have ever derived from painting. ... I was dead tired with swollen feet, aching in narrow shoes; although a petty sensation it still would have prevented me from admiring God in all his glory—but in front of this picture I totally forgot it. My heavens how beautiful it is! ... I got into the state of emotion where the *celestial sensations* of the fine arts encounter impassioned sentiments. When I left *Santa Croce* I had palpitations of the heart, felt beside myself and feared to fall down. (The syndrome, caused by an onrush of adrenaline, might not be rare. The present author prides himself on a similar attack, shaking knees included, when confronted with Cézanne's *Small Bridge*, worthy of the same exclamation, "My heavens how beautiful it is!" My sensation did not, however, have any aching feet with which to compete.)

It throws some light on the difference in expressive quality of painting and writing to note that when the mentally restless Swedish author, August Strindberg, was upset and lacked the peace of mind necessary for literary work, he turned to painting, where he found it easier to express his tormented feelings (Fig. 4).

The occasionally striking similarities in expression between the different types of art sometimes enable one to illustrate and bring out the character of a particular work by setting it against a corresponding example in another art form, as Gotthold Lessing did when he compared how the pain of Laocoon, bitten by snakes, is depicted in sculpture and in writing (p. 112).

In a famous essay this German philosopher determines the boundary between fiction and the fine arts. The essay is a product of its day and now seems absurdly punctilious: "The flow of time belongs to the writer, space to the artist. To mingle different points in time, and, for example, depict on the same canvas the entire story of The Prodigal Son with his sinful life, his misery and his return home, as Titian did, is an encroachment by painting upon the domains of fiction and is incompatible with good taste."

During many years of excursions through the provinces of art I have collected examples of writers, artists and composers in whose work I have found a convincing link between illness and creativity, comparing, for each disease, the effect on the various art forms. With no other guidance than the shallow traces left by a life on this earth, the nature of an historical person's disease is liable to remain obscure.[23] To an experienced physician, however, the patient's history may well suffice to establish a diagnosis. In the present examples the evidence has on the whole been unequivocal.

My list is not intended as a complete catalogue of human misery in art—that, indeed, would be an impossible undertaking—but rather a collage from various sources, a subjective rhapsody in black, occasionally illuminated by the fortitude and creative joy of great artists. Consequently, I do not claim to have scientific, statistical evidence. For that purpose, as a famous scientist suggested to me, I should have collected two control groups for comparison, one where ill artists had created seemingly healthy work, and another where healthy artists had created art of seemingly diseased origin. Failing that, I am well satisfied with the humanist's evidence, namely "the conviction of personal experience". The "two cultures" are still happily divorced.

A study of this kind would, I think, be of value even if

one agreed with George Bernard Shaw that "disease is not interesting; it is something to be done away with by general consent and that is all about it". John Updike adds that there are areas of life which cannot be made interesting to the reader: "Disease and pain, for instance, are of consuming concern to the person suffering from them, but their descriptions weary us within a few paragraphs." He comes close to proving his point with a lengthy account of his *psoriasis*,[88] but remains interesting and entertaining when he describes this "other presence co-occupying your body and singling you out from the happy herds of normal mankind". His skin disease may even have preserved a great writer—Updike counted himself out of jobs that demand being presentable and was left "a worker in ink who can hide himself and send out a surrogate presence". Both authors changed their mind when they themselves became ill; Shaw developed a caustic interest in his own osteomyelitis (p. 129) and Updike wrote a delightful description of his appendicitis.[87]

A cynical opinion about suffering is offered by Nietzsche who observed that a malicious pleasure in the misfortune of others is a standard complement of human character. There is more kindness in Goethe's view that "our own pain teaches us to share the misery of our fellow creatures"; it is through suffering and pain that we can identify with them: happiness may be incomprehensible, pain is readily understood.

The meaning of human misery has rarely been treated more profoundly than in the *Book of Job*. Although "he was blameless and upright . . . and turned away from evil", Job was deprived of both family and wealth and afflicted with loathsome sores from the sole of his foot to the crown of his head—"The night racks my bones and the pain that gnaws me takes no rest." Cursing the day of his birth, Job desperately asked the eternal question why

man must suffer. "Wherefore is light given to him that is in misery, and life unto the bitter in Soul?"

His friends surmised, as friends will, that it was a divine punishment and that Job must have sinned. But Job, knowing himself blameless, revolted against the injustice; incensed that his question remained unanswered, he bursts out in defiance: "Oh, that I had one to hear me! I have had my say, let the Almighty answer me!"

In the original, stern and convincing version of the tale Job remains a titanic blasphemer and does not yield; it is only in a later, meek addition that he resigns: "I had heard of Thee by the hearing of the ear, but now my eye sees Thee; therefore I despise myself and repent in dust and ashes." He is supposed to understand that suffering is not a punishment but a humbling and a purification of the mind: "He delivers the afflicted by their affliction and opens their ear by adversity." In a happy and thus unlikely end Job is then rewarded for his surrender with the restoration of health and wealth—and even with a new family! As one of the first in a long tradition, Job found that suffering affects the mood of expression: "My lyre is tuned to mourning, and my pipe to the voice of those who weep."

A similarly humble attitude toward suffering is displayed by the Renaissance scholar Blaise Pascal,[41] who unreservedly accepted health and disease, good and evil, as gifts from God. Disease was his beyond measure—his life and work were an unceasing triumph over bodily ailments. From the age of eighteen he did not have a day without abdominal pain and headaches; it has been presumed that he suffered from intestinal tuberculosis and also from migraine.

This great scientist, pioneering mathematician and physicist was profoundly religious, recognizing that human intellect alone cannot resolve the enigmas of life. In *Thoughts on Religion* he fights his doubts and demon-

strates how faith can help a human being not only to endure suffering with dignity and equanimity, but even to accept it with gratitude and confidence: "I joyously experience both the good He has bestowed on me and the evil He has sent for my own good and which His example has taught me to bear." The gratitude does not exclude a natural pessimism: "One should rather learn to benefit from evil, which is so prevalent, than from good, which is so rare."

In words reminiscent of Job, Pascal's *Prayer to the Lord* presents his credo for turning disease to good account: "Thou art the Almighty; do unto me according to Thy will. Give or take away but accommodate my will to Thine. I prepare myself to obey Thy commands in humble submission—I know not what is best for me, health or disease, prosperity or adversity. Thou alone knowest this." Pascal's conviction that disease is meaningless if we cannot believe it is sent by a Heavenly Father presaged the Enlightenment, when people began seriously to "dare to know", and more and more ceased to believe, or even hope, that there is a hidden meaning—the concept of an endless universe filled Pascal with horror. Suffering was now divested of its religious aura; disease and death came to be regarded as natural events and medicine developed as the best means "to improve health, lengthen life and ban the scourges of old age", to quote Descartes.

Ever since antiquity, artistic creation has been associated with physical stigma;[9] the conception of superior strength is inseparable from suffering. Philoctetes, the peerless archer of Greek mythology whose snakebite suppurated with a stench so horrible that his companions left him behind on a desert island, provides the essence in Sophocles' play: "I would have remained thoughtless and carefree as an animal if it had not been for the wounds... When the pain takes hold of me I know that I am

human."[97] In Gide's version, Philoctetes adds that "I have learned to express myself better, now that I am no longer with men—and I took to telling the story of my sufferings, and if the phrase were very beautiful I was so much consoled; I even sometimes forgot my sadness by uttering it."

The idea that the artist derives his power from some mutilation, that it is the damaged mussel that produces the pearl, is widely accepted—only the English romantic school is an exception. Both Wordsworth and Coleridge thought that poetry depends upon a condition of positive health in the poet, a more than usual well-being. The German romantic school, on the other hand, found suffering interesting and almost essential for creativity.[92] The idea became a leading motive, already intimated by Goethe in *Wilhelm Meisters Lehrjahre*: "About the beginning of my eighth year, I was seized with a bloodcough; and from that moment my soul became all feeling, all memory." Friedrich Schlegel relates his feelings about his near-fatal disease: "it had a fuller and deeper nature than the ordinary health of others, who seemed rather like dreaming sleepwalkers". An heroic faith in the holiness and ennobling power of pain was avowed by Hoelderlin, and Novalis, the poet of death, who died at twenty-eight from tuberculosis, experienced a mystic connection: "could disease not be a means of higher synthesis, a phenomenon of a heightened sensitivity that is about to be transformed into higher powers?" As Pascal had done, he tried to benefit from it: "Illnesses are certainly a most highly important factor of human life, since there are such numberless varieties of them and every human being has to cope with them such a lot. To date we are very imperfectly acquainted with the art of making use of them". His remarkable observation that "the more agonizing the pain, the more intense is the pleasure behind it", which borders on the masochistic, is

22

similar to Nietzsche's experience: "I have never felt happier with myself than in the sickest periods of my life, periods of the greatest pain." He welcomed suffering as a goad to creativity. Most of us would, however, prefer, like Goethe, to have suffering in the past, "The memory of surmounted pain is pleasure."

These views culminate in the pages on suffering in Schopenhauer's "Parerga and Paralipomena", so enjoyable in their clear-eyed pessimism. True to his nature, Schopenhauer sees a positive value in pain, because of the intensity of the sensation, and assigns a negative value to well-being, which he finds tedious and liable to turn into boredom. (I have not been able to console many of my patients with this argument.) Schopenhauer observes that we generally experience pain far beyond our apprehension, pleasure far beneath expectation. For anyone who thinks that enjoyment surpasses or at least balances pain he recommends comparing the feelings of a beast of prey devouring another animal to those of the victim! In sum, Schopenhauer considers that man needs suffering and pain to help keep him on a steady course, just as a ship needs ballast. Edvard Munch uses a similar metaphor: "Without illness and anxiety I would have been a rudderless ship." There was plenty of both to direct his course (Fig. 28).

Suffering has also been extolled in music. While still a young man Gustav Mahler declared that pain was his sole consolation; consequently lamenting tones sound through much of his music. He concluded, however, that the ultimate goal in art always is relief from suffering and the rising above it.

Let us end on a lyrical note and listen to this thought, pronounced by two female poets; first by the youngest and mildest of the Brontë sisters, the submissive Anne, when, dying from tuberculosis, she collected strength in her *Psalm of Resignation:*

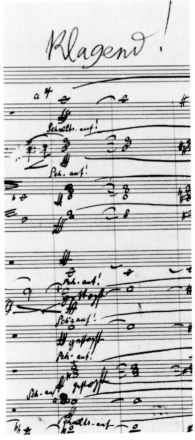

5. G. Mahler, Facsimile, Symphony no. 5, first movement. The composer laments—"Klagend".

With secret labour to sustain
In humble patience every blow;
To gather fortitude from pain
And hope and holiness from woe.

The words are repeated in Emily Dickinsons's pure and
personal, slightly trembling timbre when she was
threatened with blindness (see page 103):

Must be a Woe—
A loss or so—
To bend the eye
Best Beauty's way—

Delight—becomes pictorial—
when viewed through Pain—
More fair—because impossible
That any gain.

My loss, by sickness—Was it Loss?
Or that Ethereal Gain
One earns by measuring the Grave—
Then—measuring the Sun.

* * *

My studies of the lives of artists have led me to conclude
that many have been influenced by disease and thus I
understand the view of Kretschmer[47] that healthy, har-
monious individuals often lack the spur that incites "the
demoniac ones" to heights of genius.

An example of the latter is Lord Byron, who found
some comfort in his disability, a club-foot, noting that
"an addiction to poetry is very generally the result of 'an
uneasy mind in an uneasy body'; disease or deformity
have been the attendants of many of our best; Collins
—mad, Pope—crooked, Milton—blind".

Thomas Mann claims that a close connection exists between disease and artistic creation, "great artists are great invalids". He lets a poet in the early novel *Royal Highness* explain: "My health is poor. I dare not say unfortunately, for I am convinced that my talent is inseparably connected with bodily infirmity." Although ironically a man who enjoyed good health, he says that "disease is a means of acquiring knowledge". Thus, the fundamental themes in two of his greatest works, *The Magic Mountain* and *Doctor Faustus*, are tuberculosis and syphilis, respectively—the two chief chronic infections of his time.

Medical surroundings during adolescence or a serious disease in the family can leave profound traces even in the work of healthy artists. As Gustave Flaubert's father was a doctor with the family apartment in the hospital precinct, the boy spent his childhood in a place of suffering and death.[96] The sights when he played in the dissecting room deeply influenced his sensibility and contributed to a premature pessimism. When he began to lose both hair and teeth at an early age, he commented that "one is hardly born before putrefaction sets in". Both Keats and Charlotte Brontë were well informed about tuberculosis from the fate of their families before they fell victims themselves and Edvard Munch has given us an unforgettable memory of his dying sister in *Sick girl*.

By preventing other activity, disease may be a factor that favours artistic creation. Because of a prostatic affection with painful urinary calculi, Michel de Montaigne had to refrain from the travelling he loved and, retiring to his castle, concentrated on his essays; the enforced exile gave him the distance from which he could observe human existence, free from illusions. " 'tis a noble and dignified Disease. And were it not a good office to a man to put him in mind of his end? My kidneys claw me to the purpose."

6. *E. Munch,* The sick girl. *Engraving. The artist portrays his sister, dying from tuberculosis at the age of fifteen.*

Disease also launched the literary career of Pierre de Ronsard, the Renaissance poet.[8] When deafness abruptly destroyed his promising future in diplomacy—imagine a deaf diplomat in the world of whispers!—Ronsard returned to the delightful landscape of his boyhood and proved himself a prince of poets:[46]

I was only fifteen, when woods and hills and springs
And brooks delighted me more than the courts of Kings
There, at twilight I saw the fairies and the fays
Dancing in the meadows in the moonlight rays.

We are perhaps indebted for a wealth of good music to the asthma, which made it impossible for Vivaldi to pursue a career in the ministry. He was ordained a priest but, unable to celebrate mass, became choir master instead and later was appointed musical director.

Physical incapacity gave us another great composer, Robert Schumann, whose training as a concert pianist was terminated by affection of the right hand with paralysis of the long and ring fingers.[35] This came about when, in an endeavour to perfect his playing, he used a mechanical device to improve the mobility of these fingers, which are difficult to control separately.

He laments to his beloved Clara, "I often feel unhappy, especially as I have a pain in my hand and, to tell the truth, it keeps getting worse. I often complain to Providence, 'Good Lord, why have you done this to me?' I would have such good use for it; so much music is alive in me, ready to be expressed, and now I can hardly bring it forth, one finger stumbling over the other. It is dreadful and rather painful."

Yet Schumann did not despair, "Don't worry about my fingers," he comforts his mother, "I can compose without them, and I would hardly be happier as a travelling virtuoso. I can still improvise." We only have to listen to Poets Love (Dichterliebe) to realize, with delight, how true this was.

At the end of the last century, Henri Matisse had already entered the legal profession when disease changed his life. He became ill with appendicitis and as complications supervened he had to refrain from work for nearly a year! As a diversion he started to do some painting and became fascinated: "I discovered colour—not through other painter's work but from the way light revealed itself in nature. I had become possessed by painting and could not abstain". If Matisse had lived in our days when appendicitis is treated with operation and cured in a week's time, he might well have become a prominent lawyer instead of a pioneer of modern art.[40]

Another period of disease led to a profound change in Matisse's painting style, from keen and radical invention to a sensitive study of the light of the South. "I left

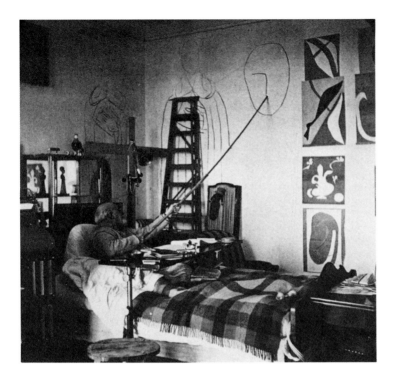

7. H. Matisse, Photo, Nice, 1949.
The artist in bed, drawing on the
wall.

l'Estaque because of the wind—it had brought on a
bothersome bronchitis. I went to Nice to cure it—and
have remained there for practically the rest of my life.''
Thus developed a new impressionism with a very per-
sonal, resplendent colouring.

Later, Matisse demonstrated that severe illness can
leave deep traces even when the patient recovers. When
over seventy he developed cancer of the colon and reluc-
tantly agreed to an operation which was performed by no
less than three of the most prominent French surgeons.
The patient's life was saved, but he was gravely ill and
greatly shaken. The wound became infected, probably
because the strong-willed master refused changing of the
bandage! As a result he acquired a bothersome large her-

nia of the scar which kept him partially bedridden for most of his remaining thirteen years.

I had a conversation with him some years later while he was lying in bed with a cat on his feet, directing with a long stick how his large cut-outs should be pasted on the canvas. He explained how his illness had altered his attitude to life and art. The new life given him he wished to fill with as much happiness as possible. During his earlier years he had often, by dint of great pain and effort,

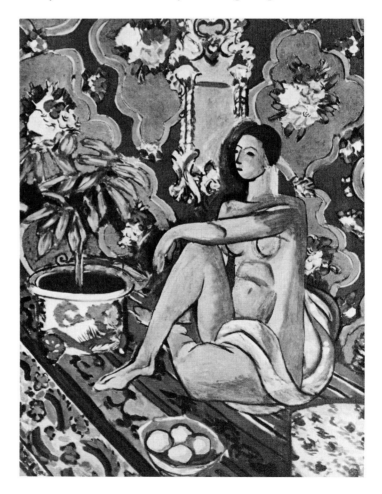

8. H. Matisse, Decorative figure against ornamental background. Wrestling with new problems, the artist attains bold harmonies, never realized before.

broken new paths in modern art (Fig. 8); now he wished to allow himself the joy of treading these paths again, light of heart and without effort. This state of mind is reflected in his pictures. In many of his early works one can see him wrestling with new problems. Over his later work rest a happy air of repose and relaxed contentment (Fig. 9). Matisse himself was so convinced of the beneficial radiation of his colour and its power to heal, that he hung his pictures around the beds of ailing friends.

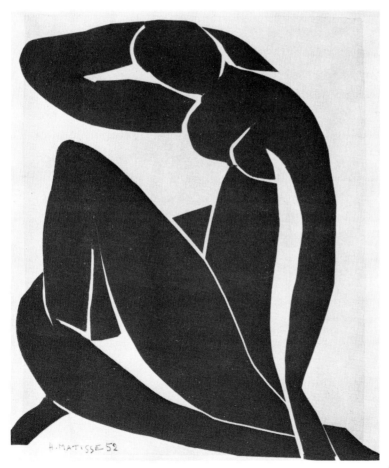

9. H. Matisse, Blue nude crouching. The late cut-outs are based on a total command of his artistic means. Their playful lightness reveals another facet of his fertile imagination and versatile personality.

Salient features of creative personality

Examples of diseases which exert a radical influence on the artist's work are to be found across the whole spectrum of pathology, mental as well as physical: "Every pain has its cry—health alone is mute." I begin with the mental conditions where one would expect to encounter the most obvious instances, considering the profound changes in personality that mental derangement may bring about.

The first question is whether artists are at all to be counted among the mentally normal, a question half answered by the saying, "there is no cure for genius". At any rate, the proportion of individuals with a borderline mental constitution is high among great creators. Aberrant psychic traits which in ordinary people would seem morbid may add to the originality and infatuation of artistic creation; they may even constitute its basis or origin.

Insanity has at times been regarded as a special asset to the creative mind. This idea has led to faulty conclusions; one of the most entertaining is related by Robert Brittain[13], editor of *Poems by Christofer Smart*:

"Knowing that Christofer Smart had been confined for madness for several years just before *A Song to David* was published, Robert Browning, in *Parleying with Christofer Smart*, jumped to the natural but quite erroneous conclusion that the great lyric was a miracle of insanity. It was an exciting theory: a mediocre poet laboriously grinding out reams of dull and uninspired verse suddenly loses his mind, and in a burst of insane genius scrawls upon the

walls of his cell a superb lyric ode worthy to be ranked
with those of Milton and Keats; then sanity returns,
genius departs and the sobered poet resumes his patient
production of trash. How such nonsense could impose
itself on a mind as intelligent as Browning's can only be
understood if one remembers the limited evidence he had
at his disposal." The poem was not, in fact, written until
after the recovery from insanity, thus not under its influ-
ence but possibly drawing from experiences of the illness.

No, "one is not a genius because one is mad" but it
may help! Handel composed *Messiah* in three hectic
weeks, his manic condition providing the requisite crea-
tive urge and power: "I thought I saw all heaven before
me, and the Great God himself." The etching that
Méryon made of *The Morgue* (Fig. 24) fascinates with its
schizophrenic lighting and the *paranoia* of August Strind-
berg throws the ghastly reflection on his hated female
characters which gives them their extraordinary radiance;
he himself believed that by incorporating them in his
fiction, he could ward off his impending insanity.

For gifted individuals, creativity may thus help to
resolve life's unavoidable conflicts and tensions.
Heinrich Heine expresses this poetically:

Disease may well have been the ground
In full for that creative urge,
Creation was my body's purge,
Creating I've grown sane and sound.

Krankheit ist wohl der letzte Grund
Des ganzen Schöpferdrangs gewesen;
Erschaffend konnte ich genesen,
Erschaffend wurde ich gesund.

He knew of a sweeter remedy (poem on
p. 80).

Graham Greene elaborates: "Writing is a form of
therapy; sometimes I wonder how all those who do not
write, compose or paint can manage to escape the mad-
ness, the melancholia, the panic fear which is inherent in

the human situation." Thus Greene indicates the essential symptoms of the two psychopathologic temperaments which prevail in creative individuals—the melancholy of the manic-depressive and the panic fear of the schizoid. Artists of both kinds share an endeavour to fortify their threatened self-esteem by vindicating independence and originality. Otherwise they differ profoundly, especially in terms of their relationships with the outside world.

The depressed have a great need for close personal contacts, to be liked and appreciated, but are held back by feelings of unworthiness. For fear of being rejected they make a bid for recognition through creative work. In *Mrs Dalloway* Virginia Woolf draws on her own experience when describing a young man becoming insane. There is the haughtiness, "Septimus, the lord of men, should be free; alone, called forth in advance of the mass of men to hear the truth,". It alternates with hallucinations of shame and despair. "So there was no excuse, nothing whatever the matter, except the sin for which human nature had condemned him to death; that he did not feel.... He lay on the sofa and made her hold his hand to prevent him from falling down, down, he cried into the flames! and saw faces laughing at him, calling him horrible disgusting names from the walls and hands pointing round the screen ... at the prostrate body which lay realizing its degradation; ... The whole world was clamouring: Kill yourself, kill yourself"—and so he did, preceding his authoress.

A tremendous urge to succeed in life and work became fatal for the manic-depressive Sylvia Plath when she feared failure. The invention of ingenious metaphors for leave-taking and death gave her solace and support, at least temporarily, when depression had deprived her of all desire to continue living "quietly, with no attachments, like a foetus in a bottle".

No metaphor, no Greek toga, could, however, in the end veil the naked, inexorable fate—her suicide:

> The woman is perfected
> Her dead
>
> Body wears the smile of accomplishment,
> The illusion of a Greek necessity
>
> Flows in the scrolls of her toga
> Her bare
>
> Feet seem to be saying:
> We have come so far, it is over.

The "Greek necessity" refers to the belief that suicide is an honourable way out of dishonour.[89]

The melancholy Michelangelo, lonely, inaccessible, *terribile*, wrote sonnets about his depressed state of mind:

> "Adversity or fortune, which would be
> my lot?
> The dark side of Life is what I got.

His paintings render his depression with even greater eloquence. In *The Day of Judgment* he lets St. Bartholomew, who suffered martyrdom by being flayed alive, display Michelangelo's own flayed skin with the head hanging and the features painfully distorted.

In contrast to the manic-depressive, the schizophrenic individual is characterized by a reluctance, even an inability, to make human contacts. The schizoid artist seeks in his work the meaning of life which others find in human community. Success may cause him to feel that he has managed to restore the lines of communication to a lost world. This feeling of alienation, sometimes exalted into a dread of fellow beings, is evident in Franz Kafka's fiction, where human society can appear incomprehensible and inconceivably malicious.

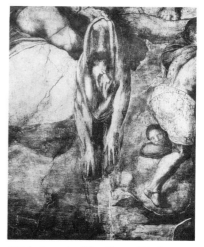

Michelangelo, The Day of Judgment, detail. The depressed artist depicts himself as a flayed martyr.

I am not qualified to comment on Freud's revolutionary thesis that man's creative mind is nothing more than a sublimation of baser instincts, of remaining infantile sexuality, with "pregenital, oral, anal, and phallic impulses"[80]. It has led some of his followers to express ideas which seem strange and repugnant to a nonpsychoanalyst, conceptions such as that van Gogh unwittingly equated his painting to masturbation. The anal component of his repressed infantile sexuality is supposed to have found an outlet in painting, where the consistency and strong odour of the paint reminded him of the faeces in which he desired to poke. Allegedly it was for this reason that he sometimes applied the paint with his fingers!

There is certainly nothing average about great creators, who generally differ from us common mortals in a variety of ways. "A poet", says Søren Kierkegaard, "is an unhappy being whose heart is torn by secret sufferings, but whose lips are so strangely formed that when the sighs and the cries escape them, they sound like beautiful music."[45]

Like curious children, great artists see everything with innocent eyes, as though for the first time; for Baudelaire, "genius is simply childhood, rediscovered by an act of will". Their unique experience and original observations are stored and matured deep in the mind for future use. "Not knowing what is coming, I bring myself into an indifferent state and wait while the forces work" says Strindberg. Artists have, above all, an urge to seek new and personal means of expression, paths of communication with fellow beings who can appreciate their new creations and share their deepest feelings, "our terrible need to make contact" in Katherine Mansfields words. This urge to deliver their message may find pathetic outlets. One of the greatest Swedish artists, Carl Hill, confined to his room by mental disease, threw his drawings out of the window to passers-by.

A true artist must be a pioneer and runs the risk of becoming a pathfinder without fans or followers. Some artists can be totally crushed by lack of appreciation and give up creative work; others, mentally stronger like Cézanne, will stubbornly continue their lonely road, far from the madding crowd.

Interestingly, this situation can prove disastrous if the artist suddenly evokes general acclaim. Mark Rothko found abrupt success intolerable after years of struggling to find a style of his own. With the typical self-depreciation of the melancholic, he feared that he was overrated, or at least misunderstood, and sank into depression and paranoia for which, as always, alcohol proved to be a poor remedy; suicide only, gave lasting relief. He could contend with adversity but not with success.

The individuality of the artist is obvious. Even if one does not agree completely with Plato and call inspiration a "divine mania", it nevertheless often appears during a state of ecstasy. Resembling a source, springing from unconscious depths of the personality, it may rise to the surface in dreams—or daydreams. Not that art constantly and effortlessly flows from the mind, or, as Thomas Mann emphasizes it "the difference between an author and an ordinary individual is that the author has greater difficulties in expressing himself."

Flaubert pursued the cult of aestheticism with almost superhuman rigor, preferring to "die like a dog than save a second by leaving a sentence before it is perfect". His endeavours were not helped by his epilepsy, which was of a rare kind that causes a frustrating, nearly unbearable difficulty in finding the right words. Hence, the deletions in his manuscripts outnumber the final text (Fig. 10).

Flaubert's successful battle with his problem illustrates beautifully that the summit of artistic achievement, the ability to handle words, paint or tones without perceptible effort, often is reached by those who have most

10. G Flaubert, Bouvard and Pecuchet. Facsimile.
"What a waste of paper, what a number of crossed-out passages. Each sentence has to be torn out of me" complained the author, whose epilepsy was of a kind that made it difficult to find the appropriate words.

difficulties acquiring the technical means, or have been restrained by incapacitating disease. Kant knew from personal experience: "It is unbelievable what a human being, even while suffering, can achieve through strong willpower—suffering might, in fact, be the only means of obtaining that height of willpower." The difficulties might be self-imposed. Demosthenes put pebbles in his mouth when practicing oratory and in our days Samuel Beckett wrote *Waiting for Godot* in French for the sake of the discipline of using a foreign language. Degas despised the easy performance of the ignorant: "The art of painting

is simple before one knows how, but difficult once one has learned."

George Sand tells about Chopin that his inspiration came on suddenly. While taking a walk, for instance, it would ring in his head and he had to hurry back to the piano to retain the musical idea on paper. Now, she says, a most heart-rending activity began. He would shut himself up in his room for days; he wept, paced back and forth, broke his pencils in pieces, changed a bar hundreds of times—erased it, wrote it again—and toiled with a single page with desperate tenacity. Eventually, he might still settle for the original draft. (cf. Cézanne, fig. 39.)

A work of art is art and work—art revealed through work unseen. Even when conceived in ardent passion and created with intense pleasure, art is usually born like other great works, with blood, sweat, toil and tears. It is simply that these alone do not suffice; if the artist loses the urge and ability for creation, he dries up and takes to repetition and mannerism. Instead of singing like a nightingale with flowing invention, he repeats, like a dove or a cuckoo, the same old melody with painful monotony. His work degenerates into an unenterprising form which "smells of ordinariness".

It remains a mystery why one artist's work touches our innermost core while another's leaves us cold and indifferent. Plato says that "he who approaches the temple of the Muses without inspiration in the belief that craftsmanship alone suffices will remain a bungler and his presumptuous poetry will be obscured by the songs of the maniacs". I dare to choose as examples de Chirico after his surrealistic period and Scott Fitzgerald after *The Great Gatsby*. These artists resemble the lilacs in a Swedish poem, "they flower fleetingly and wither slowly". Those with lasting inspiration, like Milton, could then be compared to the roses in Anakreon's ode, "The pleasing old age of the roses retains the fragrance of youth."

There are many poignant expressions for the deep despondency that artistic sterility produces, often aggravated by painful pangs of conscience over mechanical repetition of ideas already expressed before, and better. It may lead to long periods of inactivity. George Gissing gives a heart-rending description in *New Grub Street*. This vocational illness, a state of chilling impotence, as opposed to the fever of compulsive creativity, may be acute and temporary or tragically incurable.

Even an author as resourceful as Joseph Conrad was afflicted. He once complained that "the work of the last three months makes a miserable show—as for the quantity. And I have sat days and days. It is an impossible existence—there are moments when I think against my will that I must give up."[19]

Melville had to give up for good. He was one of those authors who depend entirely on a foundation of personal experience to build their fiction and thus risk exhausting their material. In crowning his sea stories with *Moby Dick*, Melville had used up the last major portion of his artistic capital, his years at sea. In a letter to Hawthorne he deplores the treasure spent: "But I feel that I am now come to the inmost leaf of the bulb, and that shortly the flower must fall to the mould", and somewhat later he told the same friend that he "had pretty much made up his mind to be annihilated".

In the last quarter-century of his life Rossini composed nothing but small pieces for his own enjoyment, pieces which he called "the sins of high age". He suffered from depression and self-reproach: "Many would, in my situation, commit suicide—but I am a coward and dare not." Recovering, he wrote a few songs which he dedicated to his wife "as a small token of gratitude for her sensible and tender care during my severe, protracted disease. The medical faculty should be ashamed of itself!"

Artificial stimulation of creativity

I can call spirits from the vasty deep.
Why, so can I, or so can any man;
But will they come when you do call for them?

(Shakespeare, *King Henry IV*, 3, I.)

We can easily understand how, in this predicament, the creator endeavours to freshen the withering lilac, how he tries to keep alive the waning inspiration by means of artificial stimulation. The Swiss artist Fuseli's recipe is really innocent: he ate raw meat in the evening in order to have splendid dreams which he then transformed into fantastic visionary images. Even more harmless was the stimulant used by Friedrich Schiller—the scent of rotting apples; this helped to evoke a mood of reverie and he therefore kept such apples in the drawer of his desk. This was not always sufficient—Goethe claims he can identify the passages Schiller wrote when he was tipsy.

What a pity we cannot question Goethe about his observations; what were the characteristics of these passages, were they really innovations or was the alcohol only deleterious? A Swedish authoress[79] who turned to drink at a time of great anxiety and strain had no difficulty, later on, to identify, line by line, the parts she had written under the influence of alcohol as they were definitely inferior.

Poets, artists and composers use alcohol for the same reason as the rest of us—to stimulate our thoughts and sentiments, to relax our minds for serious efforts, "recreational drinking", and to release the inhibitions that prevent us, average people from living fully and artists from giving free rein to their inspiration. Thomas Moore is delighted that:

If with water you fill up your glasses
You'll never write anything wise;
For wine is the horse of Parnassus
that carries the bard to the skies.

Like other drugs, alcohol may give creative work a singular, even schizophrenic character, with verbal or visual excesses and phantastic images. An alcoholic poet observes that "narcomania may impress creative work in the same manner as some insanities"! A particular therapeutic effect of alcohol is that it assuages the depression of the mano-depressives and the anxiety of schizophrenics, thereby tending to encourage overindulgence.

The kindling of creative power that alcohol can ignite must then be dearly paid for later, when the glow is covered by ashes; like all other nerve poisons, alcohol ultimately destroys the activity of the mind. The deleterious effect is noticeable in many authors. Tennessee William's creative power degenerated from the strong, original plays of his healthy middle age to the weak, murky ones of his last decades, when the abuse of alcohol gave both him and his work a crazy, outrageous turn.

Under the influence of wine Utrillo painted the most exquisite pictures of Paris, with subtle nuances in white, greys and greens. It is recounted that his relatives left him with a bottle of wine and a new canvas, returning later to fetch an empty bottle and a drunk artist, but also a fine painting, often a view of Montmartre, with its vibrant Parisian atmosphere (Fig. 11). As his dependence on alcohol increased, however, his powers were enfeebled and his means of expression diluted, as witness his later pictures, with their rather glaring, facile effects and faltering execution (Fig. 12).

Apart from alcohol, in the nineteenth century opium was the drug most commonly relied upon, especially by poets, both for stimulating creative ability and for relief

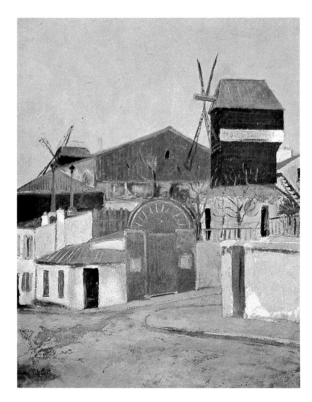

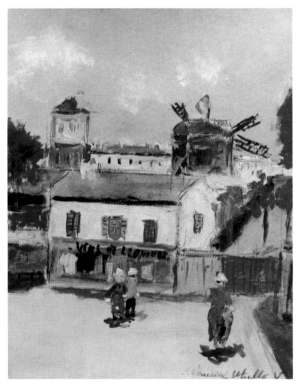

from external difficulties or internal upheaval. English Romanticism offers a number of examples. Coleridge saw the palace of Kubla Khan in a trance and sang it's praise, not quite awake: "For he on honeydew hath fed,

And drunk the milk of Paradise."

Keats also tried the drug:

My heart aches, and a drowsy numbness pains
My sense, as though of hemlock I had drunk
Or emptied some dull opiate to the drains
One minute past and Lethe-wards had sunk.

He later abstained because of its dulling effect on the mind:

11. M. Utrillo, *The windmills of Montmartre*, 1912. A slight scent of alcohol does not noticeably vitiate the subtly rendered Paris atmosphere.

12. M. Utrillo, *The windmills of Montmartre*, 1953. Forty years later, wine and liquor have moved into the centre, and the wings are cracked. The continuous change in aesthetic convention is evident from the fact that some of my young friends prefer this late, awkward painting because of its more expressive approach as compared to the artistic refinement of the early version.

No, no, go not to Lethe,
————
For shade to shade will come too drowsily
And drown the wakeful anguish of the soul.

In the mysterious twilight between reality and dreams "crowned with wreaths of poppies" we may also hear romantic music—in his *Symphonie Fantastique* Hector Berlioz resorts to the fiction of an opium dream when transforming the artist's sufferings and ecstasy into musical images. The sentimental programme provided by Berlioz could well have been conjured up by one of the Romantic poets: "A young composer of delicate sensitivity and passionate imagination has poisoned himself with opium in despair over unrequited love. As the dose was not lethal, it just threw him into a long sleep accompanied by bizarre visions where the spiritualized beloved, like a fixed idea, returns over and over again in a rapturous melody." The symphony reflects Berlioz' hysteric nature with fits of frenzy, revealed in his dramatic behaviour.[84] When his beloved deserted him he had advanced plans to shoot her and himself, disguised as a lady's maid—the pistols were already loaded! After recovering his senses he reflected cooly—a true artist, exploiting a very personal experience—"It would have made a fine scene. It really is a great pity it had to be dropped".

We know that Berlioz occasionally took strong medicine, probably containing narcotics, to relieve agonizing toothache but there is no indication that he ever used drugs to become intoxicated as De Quincey did.

This candid author of the *Confessions of an English Opium-Eater* became a slave to the craving. As he, in his own words, was "upon such a theme not simply the best but surely the sole authority", he was able to give us a deeply felt, eloquent and masterly narrative, both of the delights and of the agonies of drug abuse. He says, not in

his defense—because the habit of eating opium was rather common in his day and was not considered a vice—but as an explanation that it was not "any search after pleasure but mere extremity of pain" that first drove him into the use of opium. He states that his pain was caused by rheumatic toothache but from his description it is evident that it was something worse, namely *trigeminal neuralgia*.

This disease is characterized by attacks of piercing pain in the face, of such severity that they sometimes drive the victim into suicide. It is easily understandable that De Quincey "began to use opium as an article of daily diet". But the pain was not the main reason for his addiction; that was rather his discovery of the effect of opium on his spiritual life. He explains how he once tried to get relief from his toothache by plunging his head into a basin of cold water. This was a foolish action indeed since it is an almost infallible way of provoking neuralgic attacks: "The next morning, as I need hardly say, I awoke with excruciating pains—from which I had hardly any respite for about twenty days. On the twenty-first day—I went out into the streets; rather to run away, if possible, from my torments, than with any distinct purpose of relief. By accident, I met a college acquaintance, who recommended opium. Opium! Dread agent of unimaginable pleasure and pain! I had heard of it as I had heard of manna or of ambrosia, but no further."

De Quincey certainly manages to give the bleakest background to his experience so that we should fully appreciate his overwhelming revelation.

"It was a Sunday afternoon, wet and cheerless; and a duller spectacle this earth of ours has yet to show than a rainy Sunday in London. On my road homewards—I saw a druggist's shop, where I asked for the tincture of opium. Arrived at my lodgings I lost not a moment in taking the quantity prescribed—and in an hour, Oh heavens! What a revulsion, what a resurrection, from its

lowest depths of the inner spirit! What an apocalypse of the world within me! That my pains had vanished, was now a trifle in my eyes; this negative effect was swallowed up in the immensity of these positive effects which had opened before me, in the abyss of divine enjoyment thus suddenly revealed. Here was a panacea for all human woes; here was the secret of happiness, about which philosophers had disputed for so many ages, at once discovered; happiness might now be bought for a penny and carried in the waistcoat-pocket; portable ecstasies might be corked up in a pint-bottle."

But the poor De Quincey came to know that divine enjoyment does not last forever. The blissful dreams eventually changed and assumed an increasingly horrible character, extorting from him "suspiria de profundis", sighs from the depths:

"The sense of space, and in the end the sense of time were both powerfully affected . . . Space swelled, and was amplified to an extent of unutterable and self-repeating infinity. This disturbed me very much less than the vast expansion of time. I sometimes had feelings representative of a duration far beyond the limits of any human experience." He thus acquired a rare, tangible, sense of the relativity of space and time. The price was high:

"These changes in my dreams were accompanied by deep-seated anxiety and funereal melancholy . . . I seemed every night to descend—not metaphorically, but literally to descend—into chasms and sunless abysses, depths below depths, from which it seemed hopeless that I could ever re-ascend . . . The state of gloom which attended these gorgeous spectacles, amounting at last to utter darkness . . . cannot be approached by words."

It has been at least approached by pictures—the magnificent engravings of Piranesi, *Carceri d'Invenzione*, convey the same feelings of desperate hopelessness. In gigantic, mystically boundless buildings with fantastic

architecture, small figures lose themselves in massive flights of steps and staircases which lead nowhere—except when suddenly ending in dark space. The similarity in expression is no coincidence: Coleridge once described these imaginary prisons to De Quincey so vividly that we have no difficulty identifying the very plate (Fig. 13).

But the resemblance has deeper causes, indicating the similarity between states of depression from drug abuse and those of other origin. De Quincey no doubt recognized his own "deep-seated anxiety and funereal melancholy" in the sombre spirit that created these pictorial "suspiria de profundis" and presumed that they must stem from "visions during the delirium of a fever". They rather result from a true manic-depressive tendency. "Piranesi dwelled on these prisons with such exuberance and frenzy that we have to look for their origin in the deepest sources of his nature, in the sombre passion which penetrates his personal life."[27] He was extremely irascible and disputes with comrades could end in physical assault; he even threatened the life of a doctor whom he thought had neglected his dying child!

In between he withdrew in sullen solitude, yelling to visitors that he, Piranesi, was unavailable. His youth was haunted by pathetic and funereal visions; thus he turned from studying models in the art academy to focus on the ill and crippled who exposed their misery in Italian churches. The lugubrious and magnificent imagination which devised the mature, late edition of the *Carceri*, among the most powerful engravings ever made, with their alarming depths and melancholic obscurity, was obviously depressive.[99] There are the morbid details reminiscent of Méryon's schizophrenic etchings (Fig. 24). Victor Hugo rightly talks about Piranesi's "black brain". The horrible, disquieting effect is enhanced by the fact that this mysterious and fantastic architecture is so rational—the endless staircases are solidly supported and

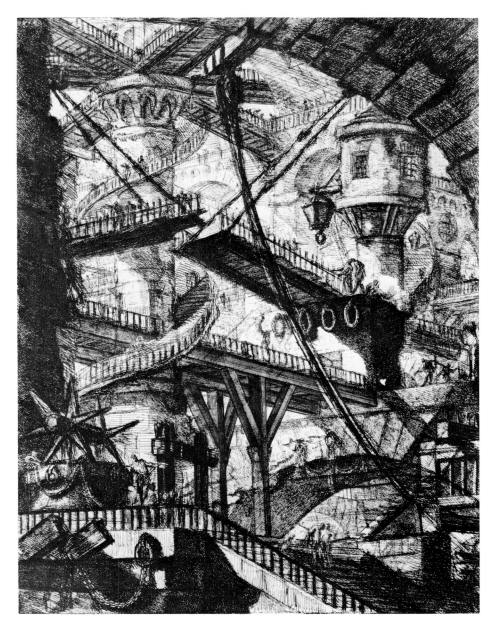

*13. G. B. Piranesi, A prison of imagination, conveys a
claustrophobic feeling of desperate hopelessness.*

14. *M. C. Escher, Hol en bol, 1955. Absurd architecture.*

the instruments of torture are technically perfect. It is the same kind of horror that Edgar Allan Poe experienced in his opium dreams and made so real in his fantastic tales, for example *The Pit and the Pendulum.*

The disorientation in space is repeated in M. C. Escher's gruesome houses where the eyes get lost in all directions and there is no telling what is in or out, up or down. This artist exemplifies that one does not have to be insane in order to create absurd works. The fact that he was probably mentally healthy and handles his means with a Northern rationality does not decrease the shocking effect of his art.

A recent addict to opium is the poet and artist Jean Cocteau, who used the drug as an aid to recover mental balance: "I preferred an artificial harmony to no harmony at all." His self-portrait in *Journal d'une désintoxication* vividly depicts the ordeal of this cure and how he was helped by creativity (Fig. 15): "Sweat and bile precede

some phantom substance which would have dissolved, leaving no other trace behind except a deep depression, if a fountain pen had not given it a direction, relief and shape.—After the cure came the worst moment, the worst danger, health with this void and an immense sadness. The doctors frankly hand you over to suicide."

The intensely tragic interest in drugs other than opium and alcohol has made its impression on art, where these

15. *J. Cocteau, Désintoxication, 1929. The painful ordeal of weaning from opium is depicted in drawings "which became the faithful graph of the last stage".*

agents have been used in an attempt to extend the frontier of human experience and to sound hitherto impenetrable depths. In drug-induced hallucinations a sharpening of the sensations is combined with dissolution of their borders. Coloured visions may assume a tactile quality and sounds may be perceived as colours. This synesthesia of images yields important information about the correlations between art forms. Both Rimbaud and Théophile Gautier, founders of the "Club des Hachichiens" in the middle of the 19th century, thought they could actually hear the sounds of colours—green, red, blue and yellow tones. Gautier relates strange experiences during hashish intoxication: "It was as if I had been dissolved into nothing, so absent and liberated from my Self, that disagreeable witness which haunts us everywhere, that I for the first time in my life could form a conception of the angels and the souls, emancipated from the body."

Baudelaire experienced the same excessive intensification of vitality, of getting "high". Once during hashish intoxication he drew a self-portrait (Fig. 16) that expresses very animatedly the feeling of being vastly superior—literally twice as tall as the Vendôme column! When sober, he suffered from disgust and void: "In order not to feel the horrible burden of Time which crushes one's shoulders and presses one to the ground, one must intoxicate oneself continually."

A strange change in the quality of conception is caused by the potent hallucinogen, mescalin. For Aldous Huxley trial of this drug was a revolutionary experience that transformed his view of human existence.[39] While admitting that the sensation was verbally incommunicable, he eulogizes it as ecstatically as De Quincey did his opium dreams: "I was seeing what Adam had seen on the morning of his creation, the miracle, moment by moment of naked existence. The flowers glowed with brighter colors—shining with their own inner light and all but quiv-

50

ering under the pressure of the significance with which they were charged."

Huxley's epitome that "visual impressions are greatly intensified and the eye recovers some of the perceptual innocence of childhood" is reminiscent of the unique characteristic of great spirits in their heaven-endowed moments of creation.

The sensation resembles but does not equate that caused by other drugs. Whereas De Quincey was horrified by a tremendous expansion of space, to Huxley "place and distance cease to be of much interest.—The mind was primarily concerned, not with measures and locations, but with being and meaning. And along with

16. C. Baudelaire, Self portrait drawn during marijuana intoxication. Strong sense of feeling "high"—compared to the Vendôme column!

indifference to space there went an even more complete indifference to time."

The state was wholly remote from human aims and striving, "it just *is*, a 'Being-Awareness-Bliss', a 'gratuitous grace'. The glory and the wonder of pure existence belong to another order, beyond the power of even the highest art to express."

As with most drugs, the return to ordinary existence, so necessary for human life and relations, is experienced as a deplorable let down, vividly described also by Nietzsche (p. 161), Gautier and Baudelaire (p. 50). In the same mood, and in peculiarly similar words, Huxley laments: "Most men and women live lives at the most painful, at the best so monotonous, poor and limited, that there is an urge to escape, a longing to transcend themselves, if only for a few moments." Huxley actually prefers mescalin to other means, such as alcohol, and even if he does not think, with Baudelaire, that in order "not to feel the horrible burden of Time—one must intoxicate oneself continually", he evidently recommends "frequent chemical vacations from intolerable selfhood and repulsive surroundings—into the world of transcendental experience". Huxley seems to indicate that such excursions through "The Door in the Wall", as H. G. Wells calls it, will benefit the artist by making him "more perceptive, more intensely aware of inward and outward reality".

Although some of the changes in consciousness occurring after mescalin are similar to those in schizophrenia, Huxley himself did not see faces or forms of men and animals. Such hallucinations were, however, frequent in the dreams of the painter and poet Henri Michaux who painted under the influence of the drug.

In those pictures we see the external sensory world transformed and animated with monstrous beings (Fig. 17). They remind us of some of the etchings of Goya who knew that *When reason sleeps, monsters appear*. Even

7. H. Michaux, Mescalin drawing.
*he surrounding world is full of
easts and monsters. The continual
petition of signs is also a schizo-
brenic symptom, perseveration.*

18. C. F. Hill, *The beasts and
monsters as seen and drawn by the
schizophrenic have an astounding re-
semblance to those drawn by
Michaux under the influence of mes-
calin.*

more striking is their resemblance to drawings by true
schizophrenics like the Swedish artist Carl Hill (Fig. 18),
which convinces us of the close connection between this
kind of intoxication and psychosis.

These artificial paradises, frequently turning into infer-
nos, thus bring us imperceptibly to mental disease. The
transition can be represented by a temporary condition,
familiar to us all, the derangement of the senses from high
fever. Aldous Huxley said that "only when I have a high

19. F. Goya could also testify that monsters appear when reason sleeps.

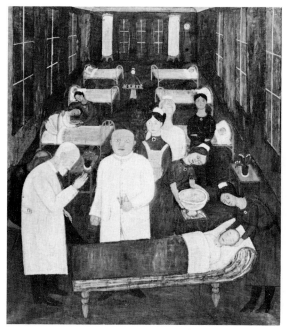

20. H. Linnqvist, The hospital ward has an anguishing atmosphere of disease and fever.

temperature do my mental images come to independent life." Artists have tried to express their delirious dreams; in *Hospital Ward* (Fig. 20) Hilding Linnqvist renders the anguishing atmosphere, smelling of antiseptics, while doctors and nurses do their rounds as observed in a trance. We are reminded of De Quincey's idea that Piranesi's prisons must stem from "visions during the delirium of fever".

Neuroses and psychosomatic disorders

The neuroses and psychosomatic disorders are of special interest to us as they strongly influence or even constitute the foundation of artistic creation. They vary greatly in character and degree. In their mildest form they may only consist of some fixed idea or of an exaggerated conception of ordinary corporeal reactions which get mistaken for disease. In their more severe form the emotional stress may give rise to an actual physical disorder like gastric ulcer or asthma. With their sensitive disposition, artists easily fall victim to this kind of illness.

At the light end of the scale there is Piet Mondrian.[56] The lifestyle of this pioneer of puristic abstract art was marked by an obsessive orderliness; he was punctilious, even finical. These peculiarities distinguished everything he undertook. He was fond of dancing and danced elaborately, according to the rules, but his movements were rigid and angular. He kept his studio meticulously clean, never a grain of dust, everything white, sparse, immaculate. This personality trait had a direct bearing on his art. His colours were absolutely pure and finally reduced to the primary prismatic, red, yellow and blue. One has the impression that when he occasionally mixed white and black to a pleasing grey (Fig. 1) he felt he was committing a daring compromise. The strictly vertical and horizontal lines are subtly distributed according to some subconscious plan and the rectangles are balanced with a pious, transcendent harmony of which he himself was aware; he was convinced that he was delivering a special message.

In the supersensitive and misanthropic Jonathan Swift,

a cleanliness mania, similar to Mondrian's, was intensified into a compulsion, inspiring the aversion to the human body and its excretions that is conspicuous in *Gulliver's Travels:*

"As soon as I entered the house, my wife took me in her arms and kissed me, at which, having not been used to the touch of that odious animal for so many years, I fell in a swoon for almost an hour. At the time I am writing it is five years since my last return to England: during the first year I could not endure my wife or children in my presence, the very smell of them was intolerable, much less could I suffer them to eat in the same room."

Gustav Mahler's fear of death and hope of resurrection, which flow as a mighty undercurrent in his music, had a medical source.[17] At an early, casual examination Mahler's doctor had discovered a heart murmur and diagnosed a harmless congenital valvular defect. This had serious consequences for Mahler's life and was of great significance for his work. His wife, Alma, relates: "the doctor said, quite brightly (as do most doctors when they diagnose a mortal disease), 'Well, this heart is nothing to be proud of!' For Mahler that was the beginning of the end. The doctor's words made an unbelievably profound impression on him." It is shocking to realize how a doctor's imprudent remarks are enough to quench the spirit of an impressionable individual.

With the best of intentions he does more harm than good by prescribing changes that prevent the patient from cultivating essential interests: "No mountaineering, no bicycling, no swimming, why, he recommended that this man, so accustomed to extreme sports, should take a "terrain cure" in order to harden himself—to walking! Starting with five minutes, then ten, and gradually increasing until he had *habituated* himself to walking." Such a prescription would have frightened anyone; of Mahler it made an anguished hypochondriac.

Alma describes his neurotic reaction. "We avoided strenuous walks owing to the ever-present anxiety about his heart. Once we knew he had valvular disease, we were afraid of everything. He was always stopping on a walk to feel his pulse; and he often asked me to listen to his heart and tell whether the beat was clear, or rapid, or calm. Mahler had a step-counter in his pocket, his steps and pulse were counted, and his life a torment". Prior to this the couple had lost a young, much loved daughter, leaving Mahler heart-broken. "Last summer, filled with worries about the lost child as well as with concern about Mahler's health, was the most difficult and sad we have spent, or shall spend together. Everything, every excursion, every attempt to divert ourselves failed. The only thing that saved Mahler was his work." In composing Mahler found consolation for his grief and a refuge from his anxiety; he turned apprehension into highly personal strains and harmonies. When we listen, with all this in mind, to *Das Lied von der Erde*, composed at that time, our hearts fill with compassion with the great composer, but also with gratitude that he was able to transform his afflictions into such beautiful music (see pages 23 and 158).

Marcel Proust's intense interest in and vivid memories of even the smallest details of ordinary life, which constitute the substance of his great autobiographical novel *A la recherche du temps perdu*, were also responsible for his neurotic disposition when they concerned his bodily sensations. His sickly disposition ever since childhood caused his parents concern. The experience of unceasing medical care generated an absorption in disease, his own and others, evident throughout the novel, and provided him with the abundance of metaphors, often astonishingly initiated in the medical domain, that is so characteristic of his literary style: "He did not release her, instead he waited like a surgeon awaits the end of the

patient's paroxysm, which has interrupted his operation, before he continues."

After the death of his mother, on whom he had a strong infantile dependence, Proust gradually withdrew from social engagements. His allergic asthma got worse and he increased the intake of potent drugs—opium, veronal and heroin—in a disastrous bid for relief. His habits became increasingly nocturnal and during long working hours in his bedroom, lined with cork to exclude noise, the great novel developed in an almost autonomic fashion; his deteriorating health made him fear he would not be able to complete the task.

Proust says himself that "Everything great in the world is created by neurotics. They have composed our master-pieces. We enjoy delightful music, beautiful paintings and thousands of small miracles, but we don't consider what they have cost their creators in sleepless nights, rashes, asthma, epilepsy—and, worst of them all, fear of death." When this eventually drew near, he observed: "A stranger has taken her abode in my mind.—I was surprised at her lack of beauty. I had always thought Death beautiful, how otherwise should she get the better of us?" George Pickering,[68] in his essay *Creative Malady*, suggests that Proust, realizing that creativity is a solitary activity, took refuge in his disease in order to procure the seclusion necessary for superhuman achievement.

The same had probably been the case with Flaubert after his father had sent him to law school: his disgust and boredom, combined with the solace he sought in the bottle, promoted the onset of epilepsy that secured his return home to the dreaming, reading and writing which engrossed him. After his father's death, when the fits had served their purpose, they conveniently subsided.

An example of how neurosis may turn into mental obsession is provided by the Swedish scientific author and professor of theology, Samuel Ödman, who in his youth

was one of Linnaeus' favourite pupils. He so feared catching cold that even the threat of a draught made him shiver. He admits himself that "your otherwise sensible friend becomes demi-maniac the moment he grasps the door-knob". For safety's sake he took to his bed at the age of forty-three and remained there for forty years, when he exchanged it for the most secluded one. "Only in his youth had he lived in the bosom of Nature. He took the picture of it with him inside the four walls that then became his outer world—as fresh as if it was from yesterday." From his miserable confinement Ödman exerted an important influence on the international world of learning of his time.

21. J. G. Sandberg, Portrait of Samuel Ödman. In order to protect himself from draughts and chills, the neurotic author stayed in bed for forty years, dressed in his coat and covered with blankets.

Mental diseases

Words will avail the wretched mind to ease
and much abate the dismal black disease. (Horace)

Mental disease exerts a profound influence on artistic activity. In fully developed cases the creative force is weakened or totally bewitched. Works of the insane have provided fundamental insight into certain manifestations of mental disorder, and in certain cases can even help us to reach a *diagnosis*. Moreover, creativity often has an excellent *therapeutic* effect.[6] There are, for instance, distressing conditions where as a result of mental disease the patient is apathetic and withdrawn, and lacks the ability to communicate with other people. If the patient can be induced to write, paint or play, the barrier may be removed so that he re-establishes contact with the environment, a change that he often perceives as an intense feeling of relief. Here is one of the links between psychiatric art and normal art. It is a fact that here, too, one of the most important inducements is a desire of the artist to communicate with his fellow men, to obtain a sense of close personal contact, and to deliver himself from suffering by creating.

To give a case history as an example: An apathetic woman stayed isolated, with no contact at all with her surroundings. When given a pencil and paper she made a drawing (Fig. 22a) which is somewhat difficult to understand. According to the specialist's interpretation, the patient has drawn a picture of herself, torn by some peculiar figures that she sees in her hallucinations. She continued to draw and in this way opened up her mind still more, so that it became easier to understand what she experienced.

22. Anonymous. Schizophrenic drawings by a mute and apathetic patient.

a. Unclear representation of hallucinations.

b. With improving capacity, the hallucination of a monster becomes clear.

In the next picture (22 b) she was able to represent more clearly both herself and the evil spirits that threaten her during her hallucinations. A patient who has been induced in this way to reveal to her physicians what is going on in her mind will often be more accessible for treatment and will then improve. In the last drawing (22 c) she has made a self-portrait but with half of the face erased; this is common for persons with her illness, schizophrenia. The patient senses a "splitting" of the personality and illustrates this with the double face. The similarity to some of Picasso's portraits is evident, and throws light on how art can disclose obscure phenomena in the emotional life of man.

Many insane individuals have a spontaneous urge to create and their art reveals symptoms of the disease. A few, with a special talent for painting, have become true artists. Through their works we are invited to explore an inner world, fantastic and totally alien to ours, either depressing or anguished (fig. 18) or reflecting a weird humour (fig. 23). This "art brut—raw vision" has attracted the interest of psychiatrists and art historians

c. Split personality expressed by half-erased face.

Fig. 23. F. Schröder-Sonnenstern, Alpha Omega. Crayon. 1951. The artist led a wild life, in and out of asylums. He explains: "I am unique—there is no double. The King of animals must receive bread and wine from the King of men, he must let the jester ride on his back while the monkey, the link between man and beasts rings the jester's bell.

alike; it has even been assigned a special museum in Lausanne, Switzerland[83]. Healthy artists have received impulses from their insane fellows which have influenced the development of art—he who goes astray, may find new paths.

A number of great artists have become frankly insane, more often schizophrenic than mano-depressive.

At the age of thirty-two, the German romantic poet Friedrich Hoelderlin who celebrated the antique ideals which he missed in his contemporaries developed symptoms characteristic of catatonic schizophrenia which deeply influenced his work. Even before, there are premonitions of the disease in his personality, a haughtiness as in paranoic megalomania, alternating with feelings of insecurity and self-contempt[32].

Hoelderlin experienced an ardent, rather romantic love for a young banker's wife whose children he taught. She reciprocated his feelings and gave in her letters moving expressions for the purity of their feelings. Diotima, as he called her, became his muse for the four years in which his poetry attained its height.

Meanwhile we—like the mated swans in their summer
 contentment
When by the lake they rest or on the waves, lightly
 rocked,—
Moved and dwelled on this earth. And though the North
 Wind was threatening
Hostile to lovers

The North Wind that threatened, "hostile to lovers", was
the menace to their fragile intimacy that one day must
end. The good husband, a more prosaic man of honour,
cannot be blamed for having a more commonplace view
of the situation—to him it was the tutor who was in
secret petting with his wife and therefor must be shown
the door. After the brutal dismissal, Hoelderlin's life was
miserable and aimless:

Desolate now is my house, and not only her they have
 taken,
No, but my own two eyes, myself I have lost, losing her.
That is why, astray, like wandering phantoms I live now
Must live, I fear, and the rest long has seemed senseless to
 me.

This incident may have had a bearing on his sudden
insanity. After the abrupt end to his position as a tutor he
roamed about for a few months and then returned home.
His mother and sister were horrified at the sight of him,
broken in mind and body, filthy and unkempt. He was
totally confused, wild-eyed, and scared the neighbours
with outbursts of rage. After a short period in an asylum
he was able to lodge peacefully with the family of a
carpenter where he lived until his death, thirty years later.
 It is noteworthy that the poet himself, as is often the
case with creative minds, had a clear conception of his

disease and its effects. Even before the symptoms were manifest he had a premonition of the change in his mind. In *Hyperion's Song of Fate* there is a vision of a schizophrenic nature[75]:

But we are fated	Doch uns ist gegeben,
To find no foothold, no rest,	Auf keiner Stätte zu ruhn,
And suffering mortals	Es schwinden, es fallen
Dwindle and fall	Die leidenden Menschen
Headlong from one	Blindlings von einer
Hour to the next,	Stunde zur andern,
Hurled like water	Wie Wasser von Klippe
From ledge to ledge	Zu Klippe geworfen,
Downward for years to the vague abyss.	Jahr lang ins Ungewisse hinab.

Then, in *The Middle of Life* at the beginning of his disease, he gives heart-rending expression to the contrast between an exuberant joy and the increasing sense of cold and the void:

But oh, where shall I find	Weh mir, wo nehm'ich, wenn
When winter comes, the flowers, and where	Es Winter ist, die Blumen, und wo
The sunshine	Den Sonnenschein,
And shade of the earth?	Und Schatten der Erde?
The walls loom	Die Mauern stehn
Speechless and cold, in the wind	Sprachlos und kalt, im Winde
Weathercocks clatter.	Klirren die Fahnen.

In the poem *Mnemosyne* he observes some symptoms, frigidity and estrangement:

A sign we are, without meaning	Ein Zeichen sind wir, deutungslos
Without pain we are and have nearly	Schmerzlos sind wir und haben fast
Lost our language in foreign lands,	Die Sprache in der Fremde verloren.

Never has the schizophrenic uncertainty about one's

identity, the feeling of being an alien to oneself, been expressed more eloquently.

Hoelderlin's insanity changed his writing as profoundly as it did his personality and appearance. His poetry did reach new heights in the early years but when the creative force had been exhausted there was a spiritual impoverishment, so that towards the end of his life not much remained. The short poems and fragments are saved by a strong feeling for nature and an unfailing sense of rhythm and style. "They shimmer like limpid raindrops after a storm, filled with boundless light; a harmony, a peace beyond all reason, perhaps just because reason has been sacrificed"[10], as in *Spring*:

> O what a joy it is for mankind! Content
> The lonely walk on riverbanks, peace, delight
> And bliss of healthy vigour bloom, and
> Not far away is kind-hearted laughter.

It is, however, with the great odes, the "night hymns" written shortly after the onset of insanity, and surely influenced by this, that Hoelderlin enters the circle of great poetic innovators. I choose as an example the most visionary, *Patmos*, the Greek island where St. John, the favourite Disciple of Christ, received his Revelations:

Near is	Nah ist
And difficult to grasp, the God.	Und schwer zu fassen der Gott.
But where danger threatens	Wo aber Gefahr ist, wächst
That which saves from it also grows.	Das Rettende auch.
In gloomy places dwell	Im Finstern wohnen
The eagles, and fearless over	Die Adler und furchtlos gehn
The chasm walk the sons of the Alps	Die Söhne der Alpen über den Abgrund weg
On bridges lightly built.	Auf leichtgebaueten Brüken.
Therefore, since round about	Drum, da gehäuft sind rings
Are heaped the summits of Time	Die Gipfel der Zeit, und die Liebsten

And the most loved live near, growing faint	Nah wohnen, ermattend auf
On mountains most separate,	Getrenntesten Bergen,
Give us innocent water,	So gieb unschuldig Wasser,
O pinions give us, with minds most faithful	O Fittige gieb uns, treuesten Sinns
To cross over and to return.	Hinüberzugehn und wiederzukehren.

In this new poetry Hoelderlin also "walks over the chasm—on bridges lightly built" and it is hardly surprising that interpretations and assessments differ so widely. Early appraisals found no literary merit and saw the linguistic peculiarities as insane distortions—an awkward accumulation of words and complex sentences that added up to a nonsensical stammer.

In the first half of this century there was a total revaluation; his writing was perceived, not as "nonsensically" but as "passionately stammering" and infinitely eloquent. According to one of the most enthusiastic interpreters[54] it is only in the years of disease that his creative force develops its full originality and strength. "The language, upset by volcanic eruptions, titanically escalated, with dizzy pitfalls in the sequence of words is a perfect expression of unbounded creative joy. *Patmos* has a surreal clarity of singular persistence and if it appears obscure, that is because it dazzles—it is created in the frightening vicinity of insanity, not surrounded by it, but vibrating with forebodings."

The assumption of a connection between the work of the poet and his insanity is supported by their parallel development. It is when the disease erupts that symptoms become apparent in the poetry, that the tone becomes agitated and "passionately stammering"; with progression of the disease and the attendant spiritual impoverishment, the poems turn simple and naive.

The bizarre style and the schizophrenic visions, bordering upon psychosis, heighten the expressiveness of the great works and give them their unique strength. It is

66

24. C. Méryon, *The morgue. Morbid details, such as a corpse
being fished out of the Seine, suggest a schizophrenic personality.*

truly remarkable that a mental derangement in the work of a great poet should be an initial influence in the universal lyrical development towards greater linguistic richness and freedom, keener images, metaphors untrammelled by conventional logic.

When reading Hoelderlin's late work one gets the impression of being in touch with the poetry of our own days. The metaphors, although beautiful, are as difficult to understand; only after re-reading, on further consideration, perhaps with help from interpreters, can one discover new and unexpected truths.

Considering the way of life of quite a number of modern poets it may be conjectured that intoxicants, including alcohol may have helped them attain the schizophrenic state in which language conventions collapse and fantastic dreams appear. Did not Coleridge perceive the palace of *Kubla Khan* in an opium intoxication and did not the perception of Huxley and the drawings of Michaux become extremely schizophrenic when they intoxicated themselves with mescalin?

One of the outstanding etchers of the last century, Charles Méryon, became schizophrenic and went through all the stages to the final mental breakdown.[52] In his famous series *Eaux-fortes sur Paris* we have the rare opportunity of following the progress of this psychosis and its relation to creativity in the works of a great artist. Even the prints that preceded obvious signs of disease reveal a schizophrenic personality—and this might account for their fascinating originality. Victor Hugo saw it: "The work of Méryon is pervaded by the breath of the infinite; the etchings are more than pictures—they are visions—his plates live, radiate light and seem even to think." His greatest work dates from the time when his psychosis was beginning to show symptoms. The remarkable etching *La Morgue* (Fig. 24) depicts a gloomy corner of the city with an oppressive atmosphere and morbid

25. C. Méryon, The Marine Ministery. In fully developed
schizophrenia the artist actually sees, and can depict, the monsters
appearing in the sky.

details. Méryon finally was confined to an asylum and his talent deteriorated—though with some lucid intervals. During one of these he created *Ministère de la Marine* (Fig. 25), where his original genius is evident in the imposing architectural majesty, while his deranged, dismal imagination produced monsters in the sky; or are they, simply, allegoric figures whose secrets are concealed in the autistic, deranged mind of the artist?

In two paintings by an eminent Swedish artist, Ernst Josephson, we have another opportunity of studying the change in artistic expression under the influence of mental disease. One of the pictures was painted while he was in sound health; the other, somewhat later, when he had become schizophrenic.

From Josephson's last summer in good health we have the painting of a young girl in the woods, a Nordic impressionism in which the soft French verdure has been replaced by the somber fir trees. A friend commented facetiously that "Joseph paints a girl picking grapes from the firs" (Fig. 26). The sunny glade has an oriental richness of colour. The spontaneous naive delight strikes us even though it is still kept in check by tight artistic reins—as is the poem from the same time which he wrote for his much loved niece, the model for the picture.

> Clad in boots and blue jacket
> I could wander through the grass where the wild
> Flowers spread their perfume.
> There stood my pine, my ash, my birch with its tender
> leaves.
> All was as in years gone by. Oh! how happy I was!

The deep impression that the disease made on Josephson's personality is discernible both in his art and in his letters. The normal mental inhibitions were dissolved and he lost control over his means of expression. But at the same time

26. E. Josephson, The artist painted his beloved niece in a sunny glade shortly before he became insane and slid into darkness.

the restraints on his creative powers were also relaxed, and these erupted with enormous force, uncontrolled and uninhibited; of the measured impressionist the disease made a savage expressionist. The picture of his uncle, a stage manager at the Royal Theatre in Stockholm (Fig. 27), is reminiscent in its darkly splendid tonal scale of the late works of Rembrandt. Josephson himself best articulates his state of mind in a letter to an artist friend, where he suggests that they should take a voyage together:

> There we will let our brushes dance in a way unknown before in Sweden. Here I haven't a single tube of colour to squeeze. Let us spite Heaven and Hell from our palates—if need be paint on the same canvas with hands and feet. The waves will dance in our pictures, the clouds float across the skies and the wind stir the grass and twigs.

The idea of painting on the same canvas with hands and feet was revolutionary at that time—today such extravagance is generally accepted. Miró, Jackson Pollock and Tapiès used the technique and Yves Klein painted with the whole body!

When Josephson thus with a violent, unbridled passion, under the influence of his insanity, lets colour and emotion take precedence over exact drawing and reason, he anticipates European expressionism; having no immediate followers, he did not pioneer it. The one who resembles him most is Edvard Munch, whose work also was influenced by a morbid, probably schizophrenic state of mind. In *The Shriek* (Fig. 28) the great Norwegian master lets a tormented figure, rendered with burning colours and agitated strokes, reveal his innermost feelings of horrible anxiety and of insecurity in his human relations.

Epilepsy was an important ingredient in the life of Dostoevsky and it influenced his work.[58] After the seizures he became depressed and listless: "for two or three days I was unable to work, write or even read, because I am a wreck, body and soul". He did not, however, experience the kind of difficulties in writing that so bothered Flaubert between attacks (p. 36); on the contrary, he generally expressed himself with remarkable ease and rapidity in a concise, rich and pictorial vocabulary. Just before the seizures he even noticed an increase in his literary output.

He exploited his experience of the disease in his fiction; no less than five of his characters are endowed with epilepsy, the foremost being Prince Myshkin in *The Idiot*. He ascribes to them the symptoms he experienced, first of all his famous pre-seizure aura, a very unusual feature in the medical literature. The aura was attended by a sense of ecstasy that he felt set him apart from other men. It was similar to that experienced by De Quincey in his opium

dreams and by Huxley when intoxicated with mescalin:

"The forces of life gathered convulsively all at once to the highest attainable consciousness. The sensation of life, of being, multiplied ten-fold at that moment; all passion, all doubts, all unrests were resolved as in a higher peace; then a peace full of dear, harmonious joy and hope. And then a scene suddenly as if something were opening up in

27. *E. Josephson, The stage director, painted during mental disease in which impetuous feelings overpower controlled drawing. "Not until Joseph went mad did he find his right mind," one of his artist friends observed.*

28. E. Munch, The shriek, an un-
bridled expression of anguish, the
fundamental horror of Man, the
"Primal Scream". "I was ill and tired
—I stood there, watching the fjord
—I felt as if a shriek went through
nature."

the soul; an undescribable, an unknown light radiated, by
which the ultimate essence of things was made visible and
recognizable. . . . this feeling is so strong and so sweet that
for a few seconds of this enjoyment one would readily
exchange ten years of one's life, perhaps even one's whole
life."

Did Dostoevsky's epilepsy also influence his philoso-

phy of life, and contribute to the foundation of his writ-
ing? An intricate question to which he himself gives an
answer:

"What do I care if it is a disease? What do I care
whether it's normal or not normal, if in retrospect and in
a healthy state, I still feel that moment as one of perfect
harmony and beauty, and if it arouses in me hitherto

*29. V. van Gogh, Self portrait
with bandage after he had cut off
part of his ear.*

unsuspected emotions, gives me feelings of magnificence, abundance and eternity, and reconciles me to everyone; if it is like a glorious, heavenly merging with the highest synthesis of life."

Epilepsy was of decisive importance also for a great painter. During Vincent van Gogh's last and most creative years, his artistic powers were influenced and liberated by an unusual kind of the disease with crises of terrible anxiety, confusion and aggression, sometimes intensified, or even brought on by absinthe intoxication. Once, during a delirious phase after threatening to kill his friend Gauguin, he cut off the lobe of his ear and presented it to a prostitute. The result of this outburst is directly visible in a self-portrait with a bandage round the head (Fig. 29). Between the crises, van Gogh had what is called *hypergraphia*, compulsive exuberant artistic activity—it is to this symptom of his disease that we owe an overwhelming number of brilliant paintings, some of them created in a single day! He, himself, felt there was something the matter: "I toil like one possessed, in a mute frenzy, more than ever. I fight with all my strength to master my art and tell myself that success would be the best lightning rod for my disease. My brushes run as fast between my fingers as the bow over a violin." In a letter from his last summer he wrote: "I am painting immense expanses of wheat beneath troubled skies, and I have not hesitated to express sadness, extreme solitude." In the final picture, *The Wheatfield* (Fig. 30), the extreme traits of his personality combine in a harrowing epitome: the manic component is reflected in the tempestuous, whirling brush strokes, the anxiety in the flock of black birds which incarnate the dismal thoughts that were soon to drive him to suicide.

It is difficult to indentify the mental derangement that ruined the life, but promoted the art of the Italian renaissance composer Gesualdo, "The mad Prince of Vesona".

That he had his wife, whom he had neglected, in spite of her unusual beauty, and her lover stabbed under his very eyes, dealing them some additional cuts himself, for the sake of pleasure, was perhaps in that irascible age not so remarkable, especially since they were caught *in flagrante delicto*. But when he, because he doubted his paternity, had his little son cruelly killed with such violent cradling that he suffocated, Gesualdo certainly exceeded normal behaviour. He is then described as an eccentric, perverse, cruel and distrustful lunatic.

In his last years, when he was no longer composing, Gesualdo was deeply depressed, on the verge of insanity, overcome by remorse for his triple crime: "he was assailed and afflicted by a vast horde of demons which gave him no peace for many days on end, unless ten or twelve young men, whom he kept specially for the purpose, were to beat him violently, three times a day"—a masochistic shock treatment if ever there was one!

His adventurous, highly strung personality is also

30. V. van Gogh, In the wheatfield there are depressive traits with the threatening sky: "The crisis caught me out in the field when I was painting on a stormy day—I felt like a coward from anxiety.—

Everything must be forced to a peak in order to arrive at those loud yellow tones."

31. C. Gesualdo, Moro Lasso al mio
duolo, 1611
Wagner, Die Walküre, Wotan kisses
Brünnhilde, 1855
 "There are harmonic passages in
Gesualdo's work to which we should
not find parallels until we come to
Wagner: compare the opening of
Moro Lasso with the famous chord
sequence in Die Walküre. Things of
this kind must certainly have seemed
crude and tentative, fantastic almost
to the point of insanity, to the histo-
rians of the eighteenth and nineteenth
centuries."[37]

reflected in his compositions, which were audacious and
fantastic, with dissonances far ahead of their time. With
the vehemence he showed in his personal life he violated
the rules and distorted the music in the interest of yet
greater expression and shrank neither from harmonic
strangeness, nor from any violent interruption in the
rhythmic flow to give vent to his inner torment[26].
Gesualdo was preoccupied with the darker aspects of life,
the tragic, the grisly and the bizarre. Slow, strange pro-
gressions of chords and short heart-rending cries of
melody are reserved for the expression of grief, suffering
and thoughts of death.

 As is the fate of so many artistic innovators, Gesualdo
was misunderstood for a long time, in his case for several
hundred years! Nothing was found in his music except
"unprincipled modulation and the perpetual embarrass-
ment and inexperience of an amateur". One of the finest
examples of his mature style, the madrigal *Moro Lasso*
(Fig. 31) was described as "extremely shocking and dis-
gusting to the ear". Opinion changed completely in the
nineteenth century and this same madrigal is now per-

ceived, not as "stammering and experimental utterances in a new idiom, but as miracles of perfected craft—one of the crowning glories of the old order of polyphony.—He is a perfect master of the short poignant phrase—precursor of the *leit-motif*—whether it be an expressive melodic fall or a striking harmonic progression"[37]. Gesualdo has taken his place as a composer of extraordinary genius whose works still live as the vivid and passionate expression of a strange personality.

Robert Schumann who alternately enjoyed manic and suffered depressive periods, had in common with van Gogh an astonishing ease and fluency of creation during his manic phases. In six days he conceived and completed the *Kreisleriana*, his most intimately subjective composition, the summit of musical romanticism. Writing to his beloved Clara Wieck, Schumann comments: "I have finished a series of new pieces which I call *Kreisleriana*. It is completely dominated by you and your thoughts and I want to dedicate them to you, and to no one else.* Then you will smile with your characteristic gracefulness and you will recognize it. My music seems so wonderfully composed, so simple, coming right from the heart. It is fantastic, mad, indeed awful; you will be astonished when you play it. Otherwise, right now, it often seems to me that I am going to burst from music!"

Even if Clara recognized the intonation, she was surely astonished at how agitated and, at times, disharmonic it was, and worried that it might not be appreciated. Like van Gogh, Schumann had expressed simultaneously in a single work the extreme duality of his nature; he lets us listen in turn to the dreaming, melancholy Eusebius and the flamboyant Florestan. In this fantastic and audacious composition, wild and demonic movements succeed tender and meditative ones with a fury that surprised

* He finally dedicated them to Chopin!

Schumann himself, enraptured by an unbridled and way-ward inspiration.

In comparison with literature and art, manifest symptoms of insanity are rare in music. There is, however, a convincing incidence in Schumann's *Fourth Symphony*, as pointed out by von Karajan, a certain continual repetition of a musical phrase, a sign which the psychiatrists name *fil circulaire* or *verbigeration*[44], corresponding to the persevering repetition of signs in art (fig. 18).

The presentiment that Schumann had expressed in his letter to Clara proved true. He had several fits of severe depression: "During the night I had the most awful thought a human can have, the most awful that Providence can punish us with—that of losing one's mind; it took hold of me so violently that every kind of consolation seemed to be a scathing mockery. The anxiety drove me to and fro, it took my breath away. I nearly expired at the thought that I might not be able to think—Clara, no suffering, no disease, no despair can be compared with that feeling of annihilation. In my extreme agitation, I ran to a doctor and told him everything, that I occasionally lost my mind, that I did not know how to escape from anxiety—yes, that I could not be depended on, could not be sure of not committing suicide in that state of utter helplessness.

"Do not get upset, my angel from heaven, just listen. The doctor consoled me amiably and ended by saying, with a smile, 'Medicine cannot help in such a case; find yourself a wife—she will cure you at once!' I thought it might work," and he sang hopefully with Heine's words:

When I note your eyes are fair	Wenn ich in deine Augen seh,
My troubles vanish into air	So schwindet all mein Leid und Weh,
But when we're kissing one another,	doch wenn ich küsse deiner Mund,
Altogether, I recover.	so werd ich ganz und gar gesund.

He followed the friendly advice but the remedy did not last. After a suicide attempt in the waters of the Rhine, he starved himself to death in an asylum where he had been interned at his own request.

Friedrich Nietzsche's disease, caused by tertiary syphilis, terminated in mental breakdown and general paralysis.[20] Symptoms of madness are increasingly evident in his last works and it is sometimes difficult to discern where health ends and disease takes over; what role, for example, did syphilis play in the begetting of "der Übermensch"? The triumphant self-assertion which characterizes the incipient madness of his last work is evident in this quotation from the somewhat bizarre *Ecce Homo:* "Genius is *conditioned* by dry air, by a pure sky—that is to say, by rapid metabolism, by the possibility of constantly procuring for oneself, great, even enormous quantities of strength." Nietzsche thus is one of those cases where severe mental symptoms in life and work are caused by organic changes in the brain.

Congenital malformations

Turning to actual physical illness, it is natural to start with the inherited disorders, the congenital malformations. Man has an instinctive loathing for these and they tend to cause aversion in fellow-beings and an irrational sense of shame in the victim. These unfortunates, then, sometimes react with bashful resignation but more often with revolt and extreme efforts to compensate, often with artistic creation. In Sir Francis Bacon's words "Whosoever hath anything fixed in his person that doth induce contempt, hath also a perpetual spur in himself to rescue and deliver himself from scorn, therefore all deformed persons are extreme bold."

Charles Lamb noticed this in Daniel Defoe, who lacked external ears: "Neither have I incurred, nor done anything to incur, with Defoe, that hideous disfigurement, which constrained him to draw upon assurance to feel 'quite unabashed' and at ease upon that article."

An excess of lineaments is equally disfiguring. Nicolai Gogol was endowed with a huge, mobile nose which made him a laughing-stock. He compensated by making comedy of his unseemly snout. In one of his stories the nose of a conceited bureaucrat mysteriously disappears and is discovered parading down the street!

The most sublime compensation conceivable is that achieved by Michelangelo. Saddened by his distorted nose, broken during a fight in childhood, the vain artist proved, by assigning the same fault to one of his divine Madonnas, that this was not incompatible with wonderful beauty.

32. The "Manchester Madonna," ascribed to Michelangelo, detail. The National Gallery, London.
The fact that the painter pictured the Madonna with a broken nose that bears a strong likeness to that of Michelangelo supports the attribution to this master.

In the early eighteenth century *The Hunchback Song*, a comic glorification of this deformity, was very popular. Its author had an enormous hump but was the first to make fun of it; hunchbacks have always had a reputation for gaiety and wit; that is why they often became jesters. On the first night of his song, the author gave a big dinner—but only hunchbacks were invited. Quite a party it must have been with all the guests bent on meat and drink!

A perfect example of the profound effect of a malformation on both life and personality, thereby influencing creative work, we find in Lord Byron, whose misshapen foot, in his own words, was his "curse of life". Byron was intensely sensitive to the deformity, which he tried to conceal in every way, and any allusion to it would drive him into a furious rage, especially when made by a female. His own mother did not hide her disgust with the child and had him subjected to extremely painful treatment by a quack, who for quite some time tried in vain to redress the deformed foot. Byron's wounded pride was decisive in forming the arrogant independence in his character and brought forth the achievements of his youthful genius. Any doubts about the connection are dispelled by his own words:

> Deformity is daring.
> It is its essence to o'ertake mankind
> By heart and soul and make itself the equal—
> Ay the superior of the rest. There is
> A spur in its halt movements to become
> All that the others cannot, in such things
> As still are free to both, to compensate
> For stepdame Nature's avarice at first.

Byron passed his life in courting agitation and difficulties, and in his fiction he has a preference for rebels like Don

33. Santeul, The Hunchback, Facsimile.
"Long ago I discovered why Punch thought it was fun to have a hunch."

Juan and Cain who are aloof, solitary and endowed with
an acute sensitivity to pain. Cain's career followed a
Byronic pattern: a malcontent, isolated from his fellow
men, he rebelled against authority and became an outcast.

In his contempt for mankind there is only one person
for whom Byron feels unbounded love and respect, his
half-sister (and half-bride?), Augusta Leigh:

Though I feel that my soul is deliver'd
To pain—it shall not be its slave.
There is many a pang to pursue me:
They may crush, but they shall not contemn—
They may torture, but shall not subdue me—
'T is of *thee* that I think—not of them.
Though human, thou didst not deceive me,
Though woman, thou didst not forsake.

Toulouse-Lautrec, who was even more conspicuously
deformed than Byron, had little choice but to resign and
withdraw. As a member of the nobility, he would cer-
tainly have been assigned a military career, had it not been

34. *H. de Toulouse-Lautrec,
In his self portraits the artist
shows his short legs and
deformed face.*

for the aberration in his bodily development with very short legs and a deformed head, evident in numerous self portraits (Fig. 34). He conformed to his situation by seeking his company among prostitutes and his motives in the brothels, where his social level was of no consequence and his appearance ignored.

To vindicate himself despite his deformity he took the motto: "Paint, drink and love" and ended up a great painter, an alcoholic with attacks of delirium tremens, and a syphilitic. Vuillard was an eye-witness: "Lautrec was too proud to submit to his lot, a physical freak, an aristo-crat cut off from his kind by grotesque appearance. He found an affinity between his own condition and the moral penury of the prostitute. He may have seemed cynical, but if so it was from an underlying despair ... I was always moved by the way in which Lautrec changed his tone when art was discussed. He who was so cynical and so foul-mouthed on all other occasions became com-pletely serious. It was a matter of faith with him ... Poor Lautrec! I went to see him one day, just after he had been put in a home in Neuilly. He hadn't long to live. He was a dying man, a wreck. His doctor had told him to 'take exercise', so he had bought a gymnasium horse—Lautrec, who couldn't even get his foot on the pedals! A cruel irony—and yet it symbolized his whole life!"

There is a notable instance of physical affliction which actually benefitted artistic performance. One of the great-est violinists of all times, Paganini, "Demon of Fiddlers", was marked by disease. Rarely has a great artist worked in such a miserable condition. There was no end to his sufferings—he was plagued by tuberculosis and syphilis, osteomyelitis of the jaw, diarrhea, hemorrhoids and uri-nary retention. The diseases and the treatment he received gave him an increasingly strange and emaciated appear-ance; the mercury prescribed for his syphilis made him lose his teeth and gave his skin a peculiar coloration.

35. D. Maclise, A drawing of the violin virtuoso Paganini demon-strates the hyperflexible joints, typi-cal of his congenital disease—look at the left thumb which could be bent back to the extent of touching the forearm!

But the most remarkable item in his pathology was a congenital disorder, the Ehlers-Danlos' syndrome, which at the same time constituted the basis for his violinistic virtuosity. The condition is characterized by an excessive flexibility of the joints. This enabled Paganini to perform the astonishing double-stoppings and roulades for which he was famous. His wrist was so loose that he could move and twist it in all directions. Although his hand was not disproportional he could thus double its reach and play in the first three positions without shifting.

This kind of disorder which usually is detrimental to the individual became in Paganini's instance artistically beneficial—it was "a blessing in disguise". And what a disguise it was! From descriptions by contemporaries we learn that his peculiar habitus, the strange, angular bendings of his body and a lividly corpse-like face gave him a freakish appearance, strangely provocative of laughter. This impression was, however, instantly suppressed when the master set the violin beneath his chin and began to play: the first stroke of his bow was like an electric spark that gave him new life. "He threw the bow on the strings and ran up and down the scales with marvelous rapidity, the cadences rippling out from beneath his fingers like strings of pearls."

His trills of ease were trills of disease. Liszt wrote in his obituary that "the wonderful meeting of such a mighty talent with circumstances so adaptable to an apotheosis will remain a singularity in the history of art..."

Old age, debility and death

Continuing now with bodily complaints, I shall turn to
the opposite side of life and proceed with the most com-
mon one, the condition that we are all bound to endure if
we are permitted to go on living, namely old age. A few,
like Milton, Titian and Verdi, continue forcefully into late
years, but for most, failing strength and increasing infir-
mity render work more difficult and cause apprehension
that one's life-work will not be achieved.

Not many of us are as stoic as Dr. Samuel Johnson
pretended to be when he remarked that the prospect of
being hanged concentrates the mind wonderfully, or as
François Villon, who had good reasons to fear that fate
and thus expected that "the halter soon would teach his
neck how much his bottom weighed".

No, for most of us death still has its sting and we feel,
with de La Rochefoucauld, that there are two things we
cannot contemplate with a steady eye: the sun and death.
Even Dr. Johnson's stoicism was affected: "No rational
man can die without apprehension." It is a trifling conso-
lation to know that we share ultimate annihilation with all
our fellow beings, and therefore, do not have to feel
deserted in our last hour.

When the time comes, we all hope to "pass away in
peace". Friedrich Schlegel had an ecstatic presentiment
that death might be welcome: "And now I know that
death also may be blissful and appealing. I understand
how a living thing in the prime of life may fondly yearn
for disintegration and release and can look ahead with joy
to the resurrection as the morning sun of hope."

36. R. Strauss, *Im Abendrot, Sunset
Glow, Facsimile. One of the last
songs of the composer.*
"Ever slower dim.—ritard espr."

Von Eichendorff almost makes us long for this with his
poem *Im Abendrot, Sunset Glow*, especially when our
souls are also swayed by Richard Strauss' glorious setting.
Although a master at prolonging finales with exquisite
"ritardandi espr", doing all he can to avoid reaching the
end, the composer felt "wandermüde, tired of wander-
ing" after a long and rich musical life. He was however
encouraged by his son to summon his forces for a last
farewell. In *Vier letzte Lieder, Four last songs*, with peace
of mind and gratitude to her who had accompanied him,
he finally welcomes death:

O rest so long desired! O weiter, stiller Friede!
We sense the night's soft breath. So tief im Abendrot.
How we are tired, tired! Wie sind wir wandermüde
Can this perhaps be death? Ist dies etwa der Tod?

A wholly contrary feeling of disgust and disillusion may
find mordant expression. Weary of life, Stagnelius, a
melancholy Swedish poet of the romantic school, invokes
putrefaction and combustion, the ultimate sufferings of
the human body.

Decay! O, do hasten my own, loved Bride
To prepare our lonely cover!
Rejected by Man and rejected by God,
I only hope being thy lover.

Embrace with affection my languishing body,
Appease in your bosom my woe.
Release into worms my thoughts and my feelings,
Into ashes my heart, burning low!

In the same vein Baudelaire was longing to become *The happy dead one*, but, detesting the mourning of men, he invited the ravens to feast upon his foul corpse and the worms to find the torture in his old body. Even *A human carcass*, rotting on the road, may be spiritualized by art. When his beloved falters from the stench, Baudelaire consoles her that once the worms have ravaged her beauty, he will have retained the form, the divine essence of her disintegrating flesh.

Although Medicine has made dying easier, not many of us will be spared the agony. Death shall ultimately tear us all asunder as wild animals rend their victims but it is the sensitive artist who most vividly can fancy the hot and stinking breath of the beast as it overpowers us.

The sudden threat of death may completely shatter creative power. This was the case with Theodor Storm[42], who developed cancer of the stomach and bade his doctor reveal the situation "as man to man". But the rather naïve author had overestimated his mental strength and collapsed on hearing the truth. To help him, his brother called in a consultant who knowingly lied that the disease was innocuous. Storm believed him without hesitation, rallied and spent an excellent summer, crowning his career with a classic work, *Der Schimmelreiter*, for which we thus have to thank a merciful fraud. But the grace was short and the vision he once had fancied became real:

So strangely weird the world becomes	So seltsam fremd wird dir die Welt,
And slowly all your hope deserts you	Und leis verläss dich alles Hoffen,
Until you know at last—at last	Bis du es endlich, endlich weisst,
That mortal shafts have struck you.	Dass dich des Todes Pfeil getroffen.

Kafka makes us understand how deserted and insecure a patient may feel when left in ignorance or deceit[90]. From the sanatorium where he died two months later, he wrote to a friend: "Verbally I don't learn anything definite, since in discussing tuberculosis everybody drops into a shy, evasive, glossy-eyed manner of speech." I believe that Storm would have regained mental balance, even knowing the truth, if he had received the right support.

When shadows fall over the road, thoughts—and hence output—increasingly concern the shortness of life and its vanity. During his last years, Eugène Delacroix was fighting weariness, weakness and a feeling of incapability as he endeavoured to conclude his most demanding task—the paintings in St. Sulpice. In *Jacob wrestling with the angel* (Fig. 37), he probably depicts his own situation of man struggling with his fate.

Paul Cézanne, the lone pioneer on a new road in art (Fig. 38), became increasingly weak and infirm with diabetes towards the end of his life and understood that his days were numbered: "I glimpse the promised land, but shall I get there, or shall I end up like the leader of the Hebrews?" Only a few days before his death he wrote to his son: "I continue working with pains, but finally something will come out of it, and that is all that matters, I believe." In his late paintings, the beloved apples are replaced by skulls in the new harmony of the spheres. Compared to the luminous character of paintings from the 'nineties, the colours are more sombre, the harmony is in the minor key and the feeling deeply tragic.

A similar development is even more obvious in the late works of Mark Rothko. With failing health, death itself

37. E. Delacroix, Jacob wrestling with the angel, is man, struggling with his fate, a losing battle. A sentence by the sorely afflicted Scott Fitzgerald, written shortly before his death, makes a fitting caption. He concludes that "life is essentially a cheat and its conditions are those of defeat, . . . the redeeming things are not 'happiness and pleasure' but the deeper satisfactions that come out of struggle."

became an obsession and is the principal theme of the murals in the Rothko chapel in Houston where light and life fade away in the almost black purple, predicting his suicide.

When the ageing Haydn found it impossible to complete his last quartet he published two movements, adding these words: "All my strength is gone, I am old and feeble." He even put them on his visiting cards to escape further demands on his ability.

In other artists we may find that the body's decline is accompanied by impoverishment of the mind, with extinction of the creative flame. For every year that passes, one or more strings of the soul snap and the tone becomes thinner. A remaining note which previously enriched the harmony then produces a shrill dissonance.

The erotic tone—often merely intimated by a simple wavy line (Fig. 40)—that endowed the works of the young Picasso with human fullness could occasionally turn into boyish mischief; it is only later, when this note is struck alone, monotonously, by the ageing man that it degenerates into pornography.

On his venturesome voyage of discovery among the

38. P. Cézanne, His apples form a new harmony of the spheres.

39. P. Cézanne, In his old age, the artist replaces the apples with skulls, the symbol of vanity.
 "He actually worked without joy, it seems, in a constant rage, in conflict with every single one of his paintings, none of which seemed to achieve what he considered the most indispensable thing, La réalisation" *(Rilke).*

curves, creases and crevices of the female body he now
neglects to tie himself to the mast, as Odysseus did, and is
seduced by his selfmade sirens into deserting his ship in
order to rape his own art and yield to the latent lust for
penetration. The spiritual vision gives way to obscene
contemplation (Fig. 41).

Even in senility, Picasso preserved a powerful faculty
of artistic expression, which makes some of his works
summits of erotic art. One would rather ascribe to him
the comment that he "painted with his penis", than to the

40. P. Picasso, *The young artist con-*
templates his model with tenderness
and discretion.

chaste Renoir who allegedly made the statement. For the latter this seems to be much too coarse a way of indicating the elementary eroticism which was the undercurrent of his inspiration.

Renoir was one of those fortunate artists whose creative powers endure into old age even when this is accompanied by more pronounced infirmities. In them one often finds a longing for the happiness of earlier years. In middle age Renoir was for a time the victim of an ambition that one sometimes finds among artists, namely to reach beyond their ability. In his efforts to adapt to the classical ideal he was liable to be dry and cold. But in his advancing years he recovered his personality. Despite painful old-age arthritis, which obliged him to tape cotton to the palm of his hand so as to be able to hold the brush, as we see in a self-portrait, he painted pictures that radiate youthful joy, and took delight in representing children, young girls and the flowers of spring (frontispiece).

The ageing Montaigne gives us a fitting caption: "Youth sees ahead, old age looks back: was not this the significance of Janus' double face? Let the years drag me

41. P. Picasso, With increasing senile eroticism, the ageing master gets seduced by his own art and makes shameless advances to his subjects, somewhat distracting his contemplation—and that of his spectators.

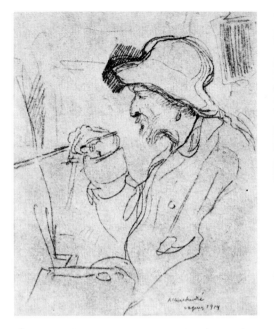

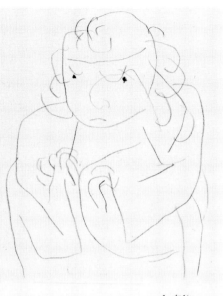

along, if they will, but then backwards! As long as my
eyes can discern that fair expired season of life, I shall
now and then turn them that way. Though youth escapes
from my blood and my veins, I shall at least not tear the
image of it from my memory. He who remembers things
past, lives twice says Martial.''

One has a feeling that Renoir, too, fondly treasured the
memory of his youth, in a healthy, vital way, and we note
the absence of constraint in his adaptation of a direct
landscape to a classical composition. His colour scale also
becomes brighter—possibly because of impaired sight,
but certainly also intentionally from a desire to achieve a
warmer tone. In this connection must be mentioned the
hypothesis that Renoir's arthrosis was an occupational
disease, caused by poisoning from his pigments. As his
light colours needed the heavy lead, he might have paid
for his radiant light, the delight of us all, with his own
health, as was probably the case with Goya (p. 105).

*42. A. Renoir, In this self portrait,
the artist shows his calloused,
horribly distorted fingerjoints.*

*43. P. Klee, The artist, struggling to
create in spite of severe disease which
crippled his hands and impeded his
wielding of the pen. (See page 149.)*

The same explanation has been given for Dufy's rheumatoid arthritis—but the medical history of this artist differed from that of Renoir in two important respects: his disease had started earlier and was even more disabling than Renoir's and it was remarkably improved by medical treatment; in the words of his doctor[38]: "The medical story of Raoul Dufy represents one of those rare instances in which a medical advance is made at exactly the right time to salvage creative functioning in an important person and thereby enrich our heritage."

This singular circumstance enables us to study not only how Dufy's art was crippled by his disease, as was his body, but also how it reverted to its original greatness and

44a. R. Dufy, Rigid lines in drawing and handwriting caused by stiff joints.

44b. R. Dufy, after treatment with anti-inflammatory hormones the lines are relaxed and the mood relieved.

perhaps even progressed further through medical treatment. This happened when Dufy was seventy-three, completely infirm and immobilized after fifteen years of disease. His drawing had become laboured and his lines as rigid as his joints.

The artist now became one of the first patients to be treated with the new hormones, ACTH and cortisone, which counteract inflammatory processes. The result was dramatic: within a few days the patient became mobile and the movements of all his joints increased. For the first time in several years he was able to squeeze his paint tubes unassisted. After six weeks Dufy was enjoying life anew, alert and active. The effect on his work is evident when one compares his handwriting as well as his pictures painted before and after treatment, when his art flourished afresh and he again became master of his means. These drugs often arouse euphoria and Dufy sensed it; he named one of the magnificent flowerpieces *Cortisone*!

Was there even a renewed progress in his creative ability? The artist thought so: "Everything continues to go well for me. Whether because of cortisone or hormones I don't know, but I am now painting themes that I studied when I was young and which naturally did not satisfy me at that time. To works constructed in the Cézanne manner I have added pure and imaginary colours, which I have been searching in vain to do for more than thirty years. Does this represent a renaissance or a swan song of Fauvism, or is it an error of my misled senses, induced by the excitement of a successful work?"

45. A. Monet, A part of nature, seen through one and the same temperament but through different eyes.

The Japanese bridge in Monet's garden in Giverny seen through the healthy eyes of the great impressionist "He is only an eye—but what an eye," Cézanne admitted.

Twenty years later, it is seen through his cataracts, which filtered away all colours except red and yellow, which instead increased in intensity. The master noticed himself that the colours became "odiously false."

Finally the motif is seen through eyes from which the opaque lens had been removed, resulting in a rebound of the colour perception toward the blue end of the spectrum "It is filthy—I see nothing but blue," the master complained.

With the help of tinted glasses Monet returned to his original colour scheme near the end of his life.

Defects of sight and hearing

The artist naturally is highly dependent on sensory perception, especially sight and hearing. These are often diminished in advanced age, but can also be impaired by disease. Of the changes in the sensory organs, one would imagine that those involving the eyes would affect the painters most deeply.[85] The colourblindness of Whistler and Léger can be discerned in their pictures. With failing sight, Degas turned from painting to sculpture when he found that in modeling he could rely more on his tactile sense. When late in life the painter Georgia O'Keefe found herself in same predicament, she also ventured into sculpture but became frustrated: "The clay controls me—I can't control it" and began longing for the compliant brush to retain her extraordinary sensitivity. Eventually she pulled one away from a girl who was varnishing and exclaimed: "I just have to hold a brush in my hand!" and with this she continued to do beautiful work in spite of her failing eyesight.

The most usual and convincing manifestation of eye affections is perhaps that resulting from senile cataract, or opacity of the lens, as we can see it in Claude Monet, one of the greatest colourists of all times.[69] One can imagine his worry and alarm when this infirmity impaired his eyesight. The influence on his painting is pathetically evident. Forms grew vague and blurred. The brush strokes became coarse, sometimes violent as from desperation. His sense of colour changed and his palette veered to red when the opaque lens filtered out most other colours; even the blue turned purple.

46. *El Greco, At the burial of the* Conde de Orgaz *the terrestrial humans are of normal shape, whereas the celestial residents are elongated, which demonstrates that the distortion is not a sign of eye affection but a means of enhancing the artistic expression.*

After a cataract operation his sight was much improved. But Monet was not at all happy when he saw the red-tinted painting from later years: "I know more than ever that the eyesight of a painter can never be recovered. When a singer loses his voice, he retires." He corrected the colour of some of his paintings; others he destroyed, even stamping them to pieces! Now that the turbid lenses had been removed, he exaggerated the blue instead—he knew this himself only from the paint tubes he chose, as they had been specially labelled. The red vision thus turned into blue: "It's filthy. It's disgusting. I see nothing but blue."

Eventually, however, his colour sense improved, much with the help of tinted glasses, and in peace he could complete his classic work, the large decorative paintings with ethereal water-lilies floating on the surface, which reflects the sky and a celestial light.

It is well established that abnormal sight was not what caused El Greco to elongate his figures.[85] As he saw nature and his paintings with the same eyes, the effect of any astigmatism would have been neutralized. Equally important is the aesthetic evidence. In several of El Greco's paintings the bodies are elongated in some places, normal in others, indicating that he used distortion purely for artistic reasons, to communicate his emotion. This is obvious in one of the great paintings of all time, *Burial of the Conde de Orgaz*. In the terrestrial region, where the corpse is being lowered into the ground, everybody is of ordinary human stature. Above, where heaven opens dramatically, even the soul of the deceased, kneeling before God, has the ethereal and ecstatic, elongated shape of the celestial residents (Fig. 46).

Since antiquity, loss of sight has been related to the gift of prophecy and poetry. Homer tells us about Demodocus, the "sacred master of heavenly song":

Loved by the Muse was the bard: but she
Gave him of good and of evil
Reft was the light of his eyes, but with
Sweetest song he was dowered.

The sweetest song seems often to be a sufficient con-
solation—Milton composed *Paradise Regained* after he
had lost his eyesight. In a famous sonnet

When I consider how my light is spent
Ere half my days in this dark world and wide,

he refers to his blindness as "a mild yoke":

"Doth God exact day-labour, light deny'd?"
I fondly ask; But Patience, to prevent
That murmur, soon replies, "God doth not need
Either man's work or his own gifts. Who best
Bear his mild yoke, they serve him best, . . .

He still at times felt heavy laden. Totally blind when
marrying his second wife, he never saw her but in fleeting
dreams. When she died, two years later, after childbirth,
he laments his double loss in a last, sublime line:

Methought I saw my late espouse'd Saint . . .
. . . as yet once more I trust to have
Full sight of her in Heaven without restraint,
Came vested all in white, pure as her mind:
Her face was veil'd, yet to my fancied sight,
Love, sweetness, goodness, in her person shin'd
So clear, as in no face with more delight.
But O, as to embrace me she inclin'd
I waked, she fled, and day brought back my night.

The blind poet found a brother in misfortune in the Bible,

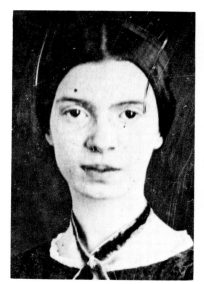

47. E. Dickinson, *In this daguerreo-
type portrait of the poet, the difference
in position of the light reflections in
the pupils shows the deviation of her
right eye. That was a trifle, enlarged
in her poetical fantasy, compared to
the squint of Dürer, who in this
drawing of himself is warding off the
confusing second image, seen by the
divergent right eye.*

Samson Agonistes, eyeless in Gaza. "O loss of sight, of thee I most complain!" the giant laments. At the time he was composing the oratorio to Milton's text, Handel was also losing his eyesight, and could enter with a similar vehemence into the feelings of the blinded Samson:

> O dark, dark, dark, amid the blaze of noon,
> Irrecoverably dark, total Eclipse
> Without all hope of day!

To all three, Samson, Milton and Handel, light, now a lost paradise, was the prime of creation:

> O first created Beam, and thou great Word,
> Let there be light, and light was over all;
> Why am I thus bereaved thy prime decree?

When those in the audience who knew the story heard this song, they could not withhold their tears.

James Joyce thought that becoming blind was the least important event in his life and Jorge Luis Borges does not find "a gradual summer twilight unbearable"; inner vision enabled him to dictate some of his finest writings during his long sightless years. The blind poet sees the unseeable without being bewildered by earthly delusion. Not seeing, he said, "leaves the mind free to explore the depths and heights of human imagination".

The thought or threat of an illness often hurts as much as the affliction itself. It has recently been established that Emily Dickinson had a squint[91] and suffered from troubled eyesight, "a woe, the only one that ever made me tremble. It was the shutting out of all the dearest ones of time, the strongest friends of the soul—BOOKS." A famous ophthalmologist in Boston treated her, probably with an operation. She was naturally upset by the thought of becoming blind: "The medical man . . . might as well

have said, 'Eyes be blind, heart be still'. . ., " the same cry of distress Beethoven had uttered when threatened with deafness.

When one compares the manifestations of impaired sensory perception in artists, it seems that deafness, rather than blindness, has the greatest impact, particularly in view of the artist's special need for contact, except of course when decreased eyesight entirely prevents creation of visual art. On closer consideration it is easy to appreciate that one gets more isolated in a silent world, more excluded from human communion when fellow-creatures can no longer be heard and one cannot participate in conversation. The loss of the familiar stream of sounds from our surroundings generates an oppressive atmosphere of deathly silence. Goya, Swift and Beethoven are convincing examples[16].

The misanthropy and depression resulting from the sudden onset of deafness penetrate the art of Francisco Goya more obviously and more intensely than that of any other. Lighthearted in his youth, "the world's happiest being" in both word and art, spreading radiant light over the beautiful figures in his early paintings, Goya was not spared the moments of melancholy that so often affect exalted spirits.[63] They were, however, light summer skies compared to the heavy thunderclouds to come. At the age of forty-seven he was struck by a fulminant disease which left him paralysed and blind for a short time and stone deaf forever.

This illness could have been caused by a rare virus but it seems more probable that Goya was poisoned by lead,[61] an important ingredient in his paint, which he handled quite recklessly, working with frenzied impetuosity. According to Théophile Gautier[30] "his method of painting was as eccentric as his talent. He scooped his color out of tubs, applied it with sponges, mops, rags, anything he could lay his hands on. He trowelled and slapped his

48. *F. Goya, In the allegory on the adoption of the constitution, Time is represented as an amiable old man.*

colours on like mortar, giving characteristic touches with a stroke of his thumb.'' Even if Gautier exaggerates, Goya must unwittingly have been exposed, intensely and massively, to the noxious effect of the paint. The resulting brain damage, *lead encephalopathy*, is known to cause deafness and personality changes—embitterment and depression.

Benumbed by his ill luck, Goya was at first quite incapable of engaging in any activity whatever, and when he eventually did resume painting his subject changed from pleasant dream to ghastly nightmare where he gave

49. *F. Goya, In the "black painting" of Saturn, Time is represented as a giant, devouring his own children, the hours, a drastic reminder of the sad fact that human time is temporary and that our moment of consciousness in the endless universe is not counted in giant figures.*

vent to the deepest despair and mistrust in all things human, as we see in, for example, the macabre "black pictures", painted during fits of melancholy in his later years.

In between he could, however, work in a lighter vein, and his misanthropic state of mind is less dominant in the pictures he painted on commission. Compare for instance the parts he assigns to Time as a symbol. The colour scale in a large decoration, *Allegory on the adoption of the constitution*, is light and festive.[72] Time is represented as an amiable old man who does not let the hourglass run empty, but turns it to indicate the beginning of a new and hopefully happy era (Fig. 48). This is quite the opposite of some black paintings Goya kept for himself. In a letter to a friend he writes: "to engage my imagination which had been almost deadened by constant brooding over my sufferings, . . . I have ventured upon a few . . . pictures. In these paintings I have been able to find room for observations that would not fit easily into work made on order, and I also could give way to my fancy and inventive powers." Consider the picture of the giant, Saturn, eating his own children, which Goya hung in his dining room (Fig. 49). True, it is again Time, now indefatigable, creating hours, but also insatiable, devouring and extinguishing them just as rapidly, thereby rendering everything meaningless. This is akin to the opinion of a modern physicist:[93] "the more the universe seems comprehensible, the more it also seems pointless."

How Goya reminds one of Jonathan Swift who also had been sociable and outgoing until, in middle age, he was robbed of his hearing. He contracted Menière's syndrome, with increasing dizziness and deafness, and laments:

See how the Dean begins to break:
Poor gentleman he droops apace,

you plainly find it in his face;
That old vertigo in his head
Will never leave him till he's dead.

The disease was an important contributory cause of his
deep mistrust of all humanity, allegorically expressed in
Gulliver's Travels; it had the most extreme manifesta-
tions, such as his "Modest Proposal" that starving Irish
children be fattened and exported to England for food!

Hearing is of prime importance for the artists who
create with sounds, the composers. Beethoven started to
lose his hearing in his twenties and spent his last years
stone deaf in that most lonely of lonely states. He found
this almost unbearable, as witness the moving words in
the "Heiligen-Städter Testament":

"O you men, who think or say I am malevolent,
stubborn or misanthropic, how greatly do you wrong
me—you do not know the secret reason for my
behaviour—consider that for six years I have been suffer-
ing from an incurable condition . . .

I am deaf—oh, how would it be possible to admit the
deficiency of a sense I ought to possess to a more perfect
degree than anybody else . . . I must live like an outcast;
when I approach a gathering I become fearful of revealing
my condition . . .

What a dejection when somebody next to me heard a
flute and I did not hear anything, or when somebody
heard the shepherd singing and I could not hear even
that—such incidents made me desperate, I was not far
from putting an end to my life. It was only Art, my art
that restrained me—oh, I felt unable to leave this world
before I had created what I felt had been assigned to me;
and so I endured this miserable life—really miserable.

Patience must be my guide from now on. I have resol-
ved, for good, I hope, to endure until the unyielding
Parcae decide to break the thread . . . To be forced to

become a Philosopher at the age of twenty-eight is not easy—least of all for an artist."

Beethoven was, however, not always guided by patience. In the *Appassionata* he bares his soul and gives free rein to despair and a heaven-storming defiance of his lamentable infirmity. But on the whole he succeeded better in becoming a philosopher than his companions in misery, the unrestrained court-painter in Madrid and the venomous Dean from Dublin. For instance, it was under these circumstances that Beethoven composed the *Pastoral Symphony*, so elevated above human misery and distress; indeed perhaps he attained these heights by a superhuman effort to endure his disability. It is pathetic to hear him rejoice in rendering the enchanting sounds of animated nature which he could hear only in memory. What he now heard, day and night, was a nasty throbbing. In his fifth symphony, Beethoven lets us understand and for a moment share his ordeal by representing it with monotonous beats on the kettle-drum against a subdued background in the strings—a musical "autopathography", if you want. We recognize Beethoven's stoic nature and may divine him smiling through the tears when the tragic mood is dispersed by an outburst of exuberant joy in the finale.

An ear specialist has made the interesting experiment of manipulating tapes of Beethoven's music from this period so that we may hear how it sounded to Beethoven with his limited auditory reception. It is enlightening but not explanatory, and it remains an open, but certainly intriguing question whether Beethoven's compositions were influenced by his impaired hearing. Did this help to free him from convention and tradition, thereby permitting the development of radically new creations? Hector Berlioz, who never learned to play an instrument correctly except the drums, might give us a clue.[7] "When I consider

the appalling number of miserable platitudes to which the piano has given birth which would never have seen the light had their authors been limited to pen and paper, I feel grateful to the happy chance that forced me to compose freely and in silence; this has delivered me from the tyranny of the fingers, so dangerous to thought, and from the fascination which ordinary sonorities always exercise on a composer, to a greater or lesser degree."

In his later years, Beethoven was certainly delivered from "ordinary sonorities" and could only perceive his compositions with his "inner ear", the inaudible music that Keats describes in *Ode to a Grecian Urn*:

> Heard melodies are sweet, but those unheard
> Are sweeter; therefore, ye soft pipes, play on;
> Not to the sensual ear, but, more endear'd,
> Pipe to the spirit ditties of no tone.

We will never know for certain the cause of Beethoven's deafness; it could have been syphilis: "It is supposed to originate in the sexual organs", but some signs indicate that he had *Paget's disease*. Beethoven's ear symptoms are precisely those found in many cases of this bone disease and he also demonstrated other characteristics. His skull grew to an impressive size, with an Olympian forehead, massive jaws and a protruding chin. Rossini describes how his eyes shone from underneath the thick eye-brows, as from the bottom of a cave.

These features are evident in portraits of Beethoven in later years. One of those, drawn four years before Beethoven's death (Fig. 50), might well illustrate an anecdote told by Bettina Brentano. Beethoven was taking a walk with his friend Goethe when they met the imperial family. The poet politely stepped aside, lifting his hat, while the headstrong composer pushed his outgrown one firmer on the head and walked straight on.

As a composer, Smetana could also describe the very sound, the buzzing in the ears, which was the first sign of the hearing disease that eventually left him deaf. In the last movement of his quartet, *Aus meinem Leben*, there is a sudden shrill tone depicting this ringing sound, the "tinnitus" which brings on the composer's despair over his approaching disability. The movement then ends in resignation to his unavoidable fate.

It is hard to imagine a more cruel game that disease has played with an artist than Gabriel Fauré's ear complaint. Not only did his hearing diminish but even the quality of tone changed so that he heard out of tune, perceiving treble tones one third above and bass tones one third below the right note. He never heard his late compositions the way he had conceived them; "I only hear horrors", the ageing master lamented.[22]

50. J. P. Lyser, a drawing of Beethoven, four years before his death, demonstrates typical signs of Paget's disease, with a large head and prominent forehead.

Agonizing pain

Severe pain is such an overwhelming sensation that it cannot be rendered artistically in all its intensity but may make a more vivid impression in art than when it is described in words. Gotthold Lessing had a very firm opinion (p 17). Discussing expressions of pain, he chooses as an example the story of Laocoon, who was killed by serpents, and compares the portrayal of the hero in the Greek sculpture with Virgil's description. In the sculpture, he says, pain is expressed, properly but not savagely and accordingly before the moment when the serpent actually strikes, while Laocoon is still only groaning and sighing. A mouth distorted by screams, as dramatically described by Virgil, would, in the figurative art, conflict with the laws of beauty and therefore preclude the free play of imagination. Lessing evidently finds this esthetically insupportable—how he would have condemned Munch's *Shriek* (Fig. 28) or Picasso's *Guernica* (Fig. 52) but approved of Matisse's subtlety (Fig. 55)!

Still many writers have penetrated the essence of pain with great feeling. Pierre de Ronsard, the Renaissance poet, had hoped to end his life in peace:

> When my time comes, Goddess, I ask of thee,
> Let me not languish long in malady.

His prayer was not heard but although he had to endure many years of severe pain from gout, rheumatism and colic, his soul was indomitable. Physical degeneration was transformed into moving, delightful poetry. What he found worst was the insomnia, pain's dismal attendant:

51. Laocoon, Greece, 50 B. C. The Vatican. The Appolonian priest was killed with his sons by two serpents when he tried to prevent the Trojans from admitting the Greek's wooden horse into Troy.

Bring back the sun, I lie harassed by pain.
I die with open eyes, tossing and turning.
For sixteen hours at least I storm
From side to side, crying
Impatient, I cannot keep quiet.
I call day vainly, and I plead with death
While she feigns deafness and keeps away.

But finally she comes to his relief:

I hail thee, happy, welcome Death,
Sovereign physic for the pain of breath!

52. P. Picasso, *In Guernica* there is an appalling expression of pain, an unrestrained, elementary reaction to immense cruelty.

Probably from personal experience, Shakespeare found that:

> There was never yet philosopher
> That could endure the toothache patiently
> However they have writ the style of gods
> And made a push of chance and sufferance.

Milton agreed:

> But pain is perfect misery, the worst
> Of evils, and, excessive, overturns
> All patience.

The two could not foresee the spiritual strength of
Immanuel Kant. This philosopher was an ascetic health
pedant with strict rules, such as always to breathe through
the nose, not through the mouth, to avoid catching com-
mon colds. He stressed the importance of a fixed time-
table for eating and sleeping and always stopped thinking
of complicated and exciting matters well ahead of bed-
time. We can therefore understand his distress when his
sleep was disturbed by disease—agonizing attacks of gout
that turned his toes a glowing red.

In a stoic attempt to distract his mind from the pain, he
forced himself to concentrate on some indifferent matter
(but no sheep-counting for a learned philosopher; the
"trivial" subject he chose was the associations conjured
up by the name *Cicero*!). This mitigated the pain, he fell
asleep and was henceforth convinced that even severe
torment can be controlled by willpower alone in most
individuals (apart from women and children, whom Kant,
a bachelor and a son of his age, pronounced devoid of
such power).

Karen Blixen, author of *Seven Gothic Tales*, showed
convincingly that strong willpower is not a male privilege.
Her husband gave her good reasons for jealousy but poor
consolation when he also infected her with syphilis (or
was it the other way around?) which was to cause her
terrible agonies. She declared that "all sorrows can be
borne if you put them into a story".

If Thomas De Quincey had been as stoic as Kant and
Karen Blixen and not surrendered to his trigeminal
neuralgia, he would probably not have become a drug

addict and we would have missed the most initiated and eloquent narration there is of the effect of both the use and the abuse of opium (p. 43). His loathing of toothache is expressive: "Two things blunt the general sense of horror which would else connect itself with tooth-ache—viz., first, its enormous diffusion; hardly a house-hold in Europe being clear of it, each in turn having some one chamber intermittingly echoing the groans extorted by this cruel torture. A second cause is found in its immunity from danger—supposing toothache liable in ever so small a proportion of its cases to a fatal issue, it would be generally ranked as the most dreadful amongst human maladies."

Abdominal colic is often a symptom of more serious illness. In the 1820s two poets in different parts of Europe suffered badly from gallstone disease—Walter Scott[66] and Esaias Tegnér[71]. They exemplify how the same disease may have entirely different effects on different per-sonalities. Their case histories were remarkably similar from a medical viewpoint—but what a disparity in reac-tion and response between the robust Scotsman, lame but steadfast, and the sensitive Swede!

Walter Scott was not overly concerned. During the attacks he roared like a bull, so that people could hear him on the road outside Abbottsford, and one night, feeling that he was dying, he bade farewell to his children; but as soon as the pain ceased he forgot his suffering.

Tegnér, on the other hand, was deeply disturbed and although witty as always, anticipated an untimely death: "New Year's Eve I got a Colic which I thought was going to bring both my poetical and theological life to a close and thereby teach me a variety of things about which both Poetics and Symbolics have left me in some uncer-tainty . . . I know that we all must die. Nevertheless, under the circumstances it would be somewhat inconvenient, if not for me, at least for my family. However, only a fool

116

complains about the inevitable. Resignation is the sum of life's wisdom and the slightest consideration should teach us to make the best of the bad bargain which we call life—a bargain which we are sure to lose anyway."

Both patients learned that even friends in need can be a nuisance; in Scott's case, the Earl of Buchan called with the Christian wish of relieving Scott's mind about the arrangements for his funeral, all of which he could safely leave in the Earl's hands! Tegnér had a friend who wrote, "Thank heavens you are well again. The news of this illness scared me terribly for good reasons: in this year alone I have lost three friends from my early days." No wonder the addressees became discouraged!

The two poets reacted quite differently to the general effect of the disease. Scott bore up courageously and wrote, "I should be a great fool, and a most ungrateful wretch to complain of such inflictions as these. My life has been, in all its private and public relations, as fortunate perhaps as was ever lived, up to this period; and whether pain or misfortune may lie behind the dark curtain of futurity, I am already a sufficient debtor to the bounty of Providence to be resigned to it."

Poor Tegnér was more pathetic—and more poetic: "I can no longer hope for health or happiness: instead I hope that God will, until the end, provide me with the strength of mind, which in our sub-lunary world so often has to substitute for Providence. If my little personage must return whence it came, to drown in the large fountainhead or float around for some time like a bubble, reflecting the sky and a strange light; whether this occurs some months sooner or later seems to be of ever diminishing importance."

The disease thus added vital elements to the two authors' experience, bringing suffering to their lives but valuable material for their work.

Their literary activity was influenced in different

53. A. Böcklin, *Agony of pain in realistic form. The Swiss master was annoyed with an unappreciative art committee. He revenged himself on the six members by sculpting their portraits in caricature. He must have been particularly mad at this one.*

degrees. Scott, with "the strength of a team of horses", continued to write during his attacks, but probably feared that the quality of his fiction suffered, because when he subsequently read what he had written in this condition he could not recollect a single incident, character or conversation: "When I was so dreadfully ill that I could hardly speak five minutes without loss of breath, I found that the exertion of dictating the nonsense ... suspended for a time the sense of my situation."

Even if Scott himself could not recollect any of the incidents he had invented while suffering, even if he thought he had dictated nonsense during his illness, it is hard for us, his readers, to agree—on the contrary, *Ivanhoe*, though written mostly between bodily convulsions, became one of his most popular romances; a beautiful demonstration of mind's triumph over matter.

The influence of the illness on writing was much more profound in Tegnér's case. His main project, *Fritiof's Saga*, had to be put aside for a while. He began using medical metaphors from his personal experience: "Even in my better, healthier days did I form Epigrams, but in a happy, light spirit. They were considered as harmless as they were meant to be, but now they are hardened, petrified bile and therefore hurting."

The disease was not the least important of the circumstances that caused a change in style and character of his poetry. Tegnér became disillusioned, often cynical, sometimes even desperate. One of his most personal poems, *The Spleen*, bears witness. It was written at a time when Tegnér was tortured by recurrent attacks of pain and fever from stones in the inflamed bile ducts:

> I reached the summit of my life
> Where waters separate and run
> With frothy waves in different directions
> It was clear up there, and wonderful to stand.

54. F. Picabia, *Agony of pain in symbolic form. His Paroxysm of Pain is actually grinding.*

I saw the Earth, t'was green and wondrous
And God was good and man was honest.
Then, suddenly, a black, splenetic demon rose
And sank his teeth into my heart.
And see, at once the Earth was empty and forsaken
And sun and stars went dark in haste

– – –

A smell of corpses runs through life,
The air of spring and summer's glory poisoned

– – –

My pulse beats fast as in my youthful days
But cannot count the times of agony.
How long, how endless is each heartbeat's pain.
O my tormented, burnt-out heart!
My heart? There is no heart within my breast;
An urn there is, with ash of life enclosed.

The two authors also provide good examples of different
attitudes to medical treatment. Scott professes early a high
opinion of doctors and their work. In his novel *Surgeon's
Daughter* he draws on personal experience when describ-
ing the hardships of a Scottish country practitioner. In
spite of them the doctor is devoted to his profession and
has no desire to trade his practice for a comfortable city
position. Scott has come to realize—and he does not
change his view after being treated for his illness—that
humanity is the physician's greatest virtue.[50]

Tegnér was dubious and sarcastic. A friend of his had
fallen ill but was dissatisfied with the treatment he was
receiving. His doctor had previously sent him some
poems, adding that he wrote prescriptions better than
poetry. This the friend had believed without difficulty but
now, he said, he feared that the doctor had been unfair to
his own poetry—a well-worded suspicion in Tegnér's
opinion.

A century after these two poets, a great French painter was racked by the same kind of torments.[2] As Henri Matisse obstinately refused to be operated for his gallstones he suffered as much and as long as his brothers in misfortune. It was, in fact, the fourth serious disease that had a profound influence on this master's life and work—first the appendicitis of his youth which was the reason why he became an artist at all, the bronchitis, the cause of the change in his painting style and then, in his seventies, cancer of the colon (see page 28), which was followed soon after by this latest problem.

For more than a year he had frequent attacks of severe pain, fever and jaundice. He was, however, more stoical than even Walter Scott; his proud nature did not permit him to complain—only his intimates knew about his agonies: "For my part, I spend most of my time in bed. I get up for an hour but, as I am not used to it, I am not very comfortable and it is with pleasure that I return to bed. I work regularly though, and paint in the afternoon." (Fig. 7.) Thus, his strong character helped him to continue creating serene masterpieces, "the calm and mighty expressions of conquered pain". Only in the illustrations for *Pasiphae* does he let us divine his ordeal. In *L'Angoisse qui s'amasse* (Increasing anguish), the agony of pain itself wields the etching-needle with fine-spun subtlety (Fig. 55).

The story of the disease of Matisse also illustrates the disadvantage of consulting several doctors, each with his own opinion: "My dear Louis Aragon, I won't go to Switzerland this summer: I am too busy with the disease and the doctors; I have two teams—1. One wants me to be operated—2. The other not. The one that advises against is presided by a surgeon—my surgeon from Lyon, who knows the risks I have been exposed to before and does not want to subject me to them again."

One evening, the medical consultations turned into a

riot and through the closed doors even the patient could hear the furious voice of Professor W. shouting that the heart of the patient would not stand an operation. No wonder Matisse proclaims: "I have some right to defend my own skin. I have no character; I like to have an attack of pain now and then and prefer evading an operation—I could not endure it." It was probably under pressure of the different opinions that he quotes an old adage: "Listening to them, one would think that all doctors are assassins—excuse me!" He might as well have quoted Ben Jonson who, three centuries earlier, likewise had been ill and dissatisfied with the medical treatment. He expressed his angry feelings *To Dr Empirick*:

> When men a dangerous disease did scape
> Of old, they gave a cock to Aesculape.
> Let me give two, that doubly am got free
> From my disease's danger, and from thee.

55. H. Matisse, Agony of pain in innate form.

Digression: artists' opinions of medicine and doctors

The irony of Matisse, the sarcasm of Jonson are echoes of numerous complaints about doctors through the ages. For the early ones, at least, there were good reasons. The treatment of Scott and Tegnér reminds us that they lived in an era when medicine had not yet entered the Age of Enlightenment and still retained many mediaeval errors. Disease was thought to be caused by some vitiated and impure matter in the blood, which had to be diverted. This idea lay behind the extensive use of bleedings, blisterings, emetics and catharsis. During one year, Louis XIII was prescribed 47 bleedings, 212 purges and 215 enemas! The king had to pay dearly for the special attention as he died young. Lord Byron's life was also shortened by excessive bloodlettings even though he defended himself irascibly. When his doctors insisted, he became utterly disgusted and expressed his conviction that more people have died from doctor's lancets than from soldiers' lances.

For centuries, men of light and learning expressed similar doubts about doctors' capacities, jokingly, sarcastically or bitterly, according to the degree of their disappointment. To Voltaire, the worst scourges of humanity are war, theologians and doctors. Montaigne[34] and Molière[12] were other sharp critics. Both suffered lingering disease and appreciated the value of health; the former says that "Health is a precious thing... without it our life becomes painful and offensive; pleasure, wisdom, science and virtue tarnish and fade away." The wise and sensible essayist was an adherent of stoicism: "We have to endure

patiently the rules of our predicament: we are going to age, to grow weak and to get ill, in spite of all medicine."

He had more confidence in the healing power of nature than in that of drugs, and he despised doctors—doubting not only their ability, but also their honour: "They have more consideration for their own reputation, and, consequently, for their profits, than for their patients' interest." He goes as far as to suggest that some doctors do not hesitate to impair the condition of their patients in order to earn more, and summarizes his opinion, "I have always despised medicine but when I get ill, I don't conform to it—instead I get to hating and fearing it and I ask those who urge me to take medicaments at least to wait until I have regained strength and health to enable me to stand the effort and the risk of taking them."

The bitter joke that one needs good health to endure medical treatment was appropriated by Molière, one of the fiercest adversaries of medicine, when he says about himself in *Le Malade imaginaire* that he was not strong enough to stand the remedies, it was all he could do to bear the disease itself.

When Molière deals with doctors, there is not a trace of his usual joviality—only the harshest mockery. "Why does he need four doctors—is not one enough to kill a patient?" His rancour was well founded:

> Your best knowledge is pure nonsense,
> Vain and imprudent doctors,
> With your fine Latin words you cannot cure
> The suffering, that is driving me to despair.

The suffering that exasperated Molière, the disease he tried to bear, was tuberculosis. While his physicians proposed treatment that could only weaken him further, his health gradually failed. The consumptive cough and the shortness of breath made stage performance increasingly

difficult. As a born comedian, he exploited his symptoms in his acting, passing them off as intentional comic turns and making the effect as irresistible as the coughing attack.

At the close of the fourth performance of *Le Malade imaginaire*, when Molière played the part of Argan, he was overtaken by profuse blood spitting and the curtain fell as rapidly on the play as on the life of the actor who could no longer make believe. Behind the bursts of laughter after this comedy[3] we will always discern the faint sound of a sob.

Antoine Watteau also died young from tuberculosis.

56. A. Watteau, *"The confounded assassins,"* members of the Medical Faculty examine the blood they have drawn from the painter and attack him with their enema syringes.

He shared in painting the same low opinion of medicine that Montaigne and Molière expressed in words: their doctors appear, drawn to life in one of his paintings (Fig. 56). He depicts himself already at the cemetery, wrapped in his dressing gown, trying to escape his tormentors, the Medical Faculty who attack him with their enema syringes. The very thought of death is with him, barely concealed by his usual graceful fancy, but with a shrill tinge bordering on the grotesque. Only in the inscription does the cry of distress, pain and agony break from his lips without restraint: "What have I done, confounded assassins, to so incur your wrath?" In order to enjoy fully the scenes described by Molière and depicted by Watteau we may add an accompaniment by Rossini as in tones he ridicules Doctor Bartolo, the basso-buffoon in *The Barber of Seville.*

Through the chorus of excited voices condemning the medical profession we may discern a soft note of appreciation played by the composer Marin Marais (1656–1728). After foresightedly having written his will, Marais evidently underwent an operation for stone in the bladder—at any rate he wrote a beautiful piece for viola entitled *Description of the Cystotomy*, one of the earliest examples of instrumental program music. He sounds still agitated when describing with rapid notes the sequences of the painful and dangerous procedure, which in those days was so dramatic that tickets were sold to people who wanted to watch the horror.

Two strong servants held the legs of the victim (Fig. 57) while a third one sat astride on his chest, holding up the scrotum. The "surgeon" introduced a metallic catheter through the urinary duct into the bladder and then made a rapid incision toward its tip through the perineum. When the bladder was opened, the stone was delivered with a forceps. The mortality rate of the procedure was 60%.

These are some headings of the composition: "The

57. Anonymous, An illustration of the operation for stone in the bladder in the eighteenth century.

decision to mount—in position—folding of the table —tying the legs up to the arms—the incision—introduction of the forceps—here the stone is delivered—here the legs are released—here one is put back to bed." No wonder the composer, after such an ordeal, needed no less than three gay dances fully to express the extent of his relief and the pleasure of recovery (see page 163).

A similar rapturous delight was expressed half a century earlier, by the diarist Samuel Pepys, when he had been relieved of a bladderstone, as large as an apple. He ordered a richly carved casket as a fitting receptacle and celebrated each anniversary of the operation with a sumptuous dinner for a number of brothers-in-misfortune. The guests circulated their trophies, one more gorgeous than the other, for general admiration, mutual thanksgiving and praise: "We were very merry all the afternoon, talking and singing and piping upon the flagolette".[73]

On the whole, however, physicians continued to be in low esteem and even in the nineteenth century Goya had good reason to feel contempt for his doctors, whom he

58. *F. Goya, The disappointed painter saw the doctor as a donkey at the bedside.*

Goya agradecido, á su amigo Arrieta: por el acierto y esmero con q. le salvó la vida en su aguda y peligrosa enfermedad, padecida á fines del año 1819. á los setenta y tres de su edad. Lo pintó en 1820.

59. F. Goya, Many years later he changed his mind and expressed gratitude to the doctor who saved his life.

represents as donkeys sitting at their patient's bedside. Ultimately, medicine developed into science and in his old age Goya found it fair to inscribe a double portrait of himself and his doctor (Fig. 59) as follows, "Goya, in gratitude to his friend Arrieta, whose skill and care saved his life during the severe and dangerous illness from which he suffered at the age of seventy-three." In this picture, the ageing master, by virtue of his art, gives individual and lasting presence to the brief moments that precede extinction.

One of the last, but by no means the least rancorous of doctor-haters was George Bernard Shaw.[74] The background is that he became ill with caries of a leg. This generally is a lingering disease, especially when, as in Shaw's case, fragments of dead bone are formed which often have to await nature's expulsion. In severe cases even amputation might be considered. Shaw's patience was limited and he became sick to death, or rather furious with his doctor:

"The tragedy of illness at present is that it delivers you helplessly into the hands of a profession which you deeply mistrust." He gave free rein to his scorn and disgust in *The Doctor's Dilemma*. It was above all the fact that doctors have a pecuniary interest in the patient's disease that upset him. In the preface to the play he argues: "I cannot knock my shins severely without forcing on some surgeon the difficult question: 'Could I not make a better use of a pocketful of guineas than this man is making of his leg? Could he not write as well—or even better—on one leg than on two? . . . artificial legs are now so well made that they are really better than natural ones." It is hard to tell whether Shaw would have written better on one leg—but it certainly would have set fire to him! The rage once expressed by Montaigne and later by Molière rings again in his observation that "It is simply unscientific to allege or believe that doctors do not under

existing circumstances perform unnecessary operations and manufacture and prolong lucrative diseases. Shaw's severe criticism of the "existing circumstances" that doctors had an economic interest in the patient's illness led to early steps towards socialized medicine in Great Britain.

Virginia Woolf felt only contempt for psychiatry and showered her bitterness both on a general practitioner and on a specialist. The former "brushed it all aside—headaches, sleeplessness, fears, dreams—nerve symptoms and nothing more. If he, Dr Holmes, found himself even half a pound below his weight, he asked his wife for another plate of porridge at breakfast.—Take up some hobby—did he not owe his own excellent health to the fact that he could always switch off from his patients on to old furniture?—'So, you're in a funk' he said agreeably, sitting down by his patient's side. . . . Wouldn't it be better to do something instead of lying in bed?"

The specialist saw directly that it was a case of extreme gravity. "To his patients he gave three-quarters of an hour. When a man comes into your room and says he is Christ (a common delusion), or threatens, as they often do, to kill himself—we all have our moments of depression—you order six months rest in bed; rest without friends, without books, without messages.—Not only did his colleagues respect him, his subordinates fear him, but the friends and relations of his patients felt for him the keenest gratitude for insisting that these prophetic Christs should drink milk in bed, as sir William ordered."

This is not the last time we meet such sarcasms—disappointment with medical treatment of incurable disease is, alas, still with us. The prescription of potent drugs can be like trying to exorcise the Devil with Beelzebub. The dying Flannery O'Connor was forced to realize that "the medicine and the disease run neck and neck to kill you".

Tuberculosis

In the history of creative work, there are many who, like Watteau and Molière, had their efforts influenced and their lives shortened by tuberculosis. One has the impression that this disease often exerted a singular effect on their talent. The slight fever livened the associations and filled the thoughts with fantastic, dreamlike pictures. A greater zest for life, which could not be satisfied in reality because of the lassitude produced by the disease, finds an outlet instead in imagination, "the mind's internal heaven[98]", often with an erotic touch. In Watteau's later paintings, in particular, we find these pathetic, impassioned attempts to keep hold of fleeting joy during lessons of love and to remain on Cythera—the island where no worries or suffering exist.

In *The Lesson of Love* the lone musician is playing to a pretty girl who is turning away from him. Carl Nordenfalk[62] suggests that this guitar-player is a "symbolic self-portrait, the melancholic consumptive to whom it was never given to drain the cup of life's pleasure, which he so brimmingly offers us in his art" (Fig. 60).

In *Pilgrimage to Cythera*, Kenneth Clark[18] sees the resemblance to the ailing Mozart, probably also suffering from tuberculosis, as well as from progressive uremia, and thus well aware of the ephemeral nature of human pleasures: "The delicate relationship between these men and women who have spent a few hours on the Island of Venus and must now return reminds one of the rapturous stirrings that precede the departure of the confident lovers in *Cosi fan tutte*."

We find the same feeling of sweet sadness in the poetry of Keats and in Chopin's *Nocturnes*—these tenderly melancholic feverdreams. Both suffered from consumption and the poor, deserted Chopin worked himself to death during the last stages of disease. He was then in London, the same place to which Carl Maria von Weber once had traveled, feverish, suffocating and spitting blood

60. A. Watteau, In "The Lesson of Love," the guitar player might be a symbolic self portrait, a melancholic consumptive.

to attend the first night of his opera, *Oberon*, and, shortly therafter, the last night of his life. In the *Funeral Sonata*, Chopin expresses the agony that seized him on leaving Valdemosa monastery after his last sojourn with George Sand. The famous Funeral March is interrupted for a few moments by a nostalgic remembrance of happier days but soon succeeded by a presto that has been compared to the flutter of the night breeze among tombstones—the concert where no encores are granted.

John Keats had a medical education and was aware of his fate after nursing his brother, who died young from tuberculosis. Describing the ominous event of his own disease, a profuse hemorrhage of the lungs, he writes to his fiancée[86]: "On the night I was taken ill—when so violent a rush of blood came to my lung that I felt nearly suffocated—I assure you I felt it possible I might not survive, and at that moment thought of nothing but you."

He sees the progress of his disease and the nature of his expectorations with the eyes of a doctor: "I know the color of that blood—it is arterial blood—I cannot be deceived in that color; that drop is my death warrant. I must die."

He tries to calm Fanny, his "dearest girl", by using moderation in speech; "this is unfortunate" and, as all humans, he at least makes an effort to deceive even himself, probably kindly supported by the euphoria which characterizes his disease: "'Tis true that since the first two or three days other subjects have entered my head. I shall be looking forward to Health and the Spring and a regular routine of our old walks."

In his last years, consumed by a hopeless passion and wasted by disease, inappropriately treated, he reflects on the relations between disease and creation: "How astonishing does the chance of leaving the world impress a sense of its natural beauties on us."

Ode to a Nightingale, a love song to the ecstasy and

eternal joy of life, is imbued with a conflicting longing for
death as he had seen it in his brother:

> Fade far away, dissolve, and quite forget
> What thou among the leaves hast never known,
> The weariness, the fever, and the fret
> – – –
>
> Where youth grows pale, and spectre-thin, and dies;
> Where but to think is to be full of sorrow
> And leaden-eyed despairs;
> – –
>
> Already with thee! tender is the night
> And haply the Queen-Moon is on her throne,
> – – –
>
> Now more than ever seems it rich to die,
> To cease upon the midnight with no pain,
> While thou art pouring forth thy soul abroad
> In such an ecstasy!
> – – –
>
> Thou wast not born for death, immortal Bird!

(Because his song remains the same through the cen-
turies):

> Perhaps the self-same song that found a path
> Through the sad heart of Ruth, when sick for home,
> She stood in tears amid the alien corn.

Man is born for death, since our songs are unique and our
personality dies with us.

During the 19th century tuberculosis continued to reap
a terrible harvest among youth and many promising artis-
tic careers were cruelly severed. After the Keats brothers
there were the Brontë sisters. Fatal disease and bouts of
depression combine with poverty and a lonely life among
the barren moors to form the gloomy background of their

Anne Brontë

By my daughter Charlotte
p. Brontë Illu?

61. C. Brontë, The writer has drawn
a delicate portrait of her mild and
submissive consumptive sister Anne.

melodramatic fiction, which so well reflected contempor-
ary, sentimental taste. Since the two oldest girls had died
in childhood from galloping consumption, it was left to
the third, Charlotte, to bring up and soon also to nurse
the two youngest. They differed a great deal from one
another. Emily, who was able to complete *Wuthering
Heights*, a solitaire of strange and singular lustre, before
she succumbed to the disease, was withdrawn and head-
strong, a lonely wanderer on the moors, whereas the

youngest, Anne, who wrote ethereal verse like the *Psalm of Resignation* (page 24), was mild and submissive.

This difference also characterizes their reaction to the disease. The proud Emily sought solitude like a wounded animal and was reluctant to receive either care or compassion, while Anne thankfully accepted both.

Seeing her sisters die, Charlotte became intimately and tragically acquainted with the symptoms of progressing pulmonary tuberculosis; her descriptions in the chapter *The Valley of the Shadow of Death* are more vivid than those of any doctor. There is the ominous loss of appetite: "palatable food was as ashes and sawdust to her", replaced by increasing thirst.—"She felt her brain in strange activity: her spirits were raised; hundreds of busy and broken, but brilliant thoughts engaged her mind... The sick girl wasted like any snow-wreath in thaw; she faded like any flower in drought." The helpless doctors are ridiculed: "One came, but that one was an oracle: he delivered a dark saying of which the future was to solve the mystery, wrote some prescriptions, gave some directions—the whole with an air of crushing authority—pocketed his fee, and went. Probably, he knew well enough he could do no good; but didn't like to say so." But Charlotte knew, "one alone reflected how liable is the undermined structure to sink in sudden ruin". The exhausted patient herself is torn between feelings of satiety with life and agony of death: "she usually buried her face deep in the pillow, and drew the coverlets close round her, as if to shut out the world and sun, of which she was tired; more than once, as she thus lay, a slight convulsion shook the sickbed, and a faint sob broke the silence round it. 'God grant me a little comfort before I die!' was her humble petition, 'sustain me through the ordeal I dread and must undergo!'"

Feverish dreams and failing strength announce the end. "Oh! I have had a suffering night. This morning I am

worse. I have tried to rise. I cannot. Dreams I am unused to have troubled me." The desperately helpless nurse-sister prays humbly but demandingly, "with that soundless voice the soul utters when its appeal is to the Invisible: Spare my beloved,—Rend not from me what long affection entwines with my whole nature." She recognizes with horror the symptoms that announce the final extinction and resigns: "the watcher approaches the patient's pillow, and sees a new and strange moulding of the familiar features, feels at once that the insufferable moment draws nigh—and subdues his soul to the sentence he cannot avert, and scarce can bear!"

At the end of her difficult life Charlotte did indeed experience perfect but brief happiness in a late marriage. But in keeping with her misfortunes the token of her happiness—pregnancy—proved fatal, the *nausea gravidarum*, the vomiting and other strains caused her tuberculosis to flare up and end her life.

In his autobiographical *Ordered South*,[78] Robert Louis Stevenson describes the stages whereby the tubercular is "tenderly weaned from the passion of life". Two Northern poetesses who died young exemplify how the disease first produces an intense zest for life and then gradual lassitude. Harriet Löwenhjelm is touchingly lonely and foresaken in her disease:

> Am I tired unto death,
> rather tired, very tired,
> ill, and sad, and tired.

Edith Södergran expresses an ecstatic and defiant feeling for life:

> We should love life's long hours of disease
> and narrow years of yearning
> As we love the short moments when the desert
> blossoms

62. *Harriet Löwenhjelm Death is waiting for the artist, ill at a sanatorium.*
"But tired and smiling we leave
* our toys*
when it's over and life is done."

Her later poetry is marked by cool resignation and a transcendental entering into the spirit of death:

> I long for the land that is not,
> For all things that are, I'm tired of desiring.

Like Keats, Anton Chekhov, another victim of tuberculosis, had a medical education: "Medicine is my lawful wife, literature my mistress. When one gets on my nerves I spend the night with the other." The parable indicates his real love, he soon spent both day and night with his "mistress" and the "lawful wife" was sorely neglected —but never forgotten: "Medicine significantly extended the area of my observations, enriched my knowledge, and only one who is himself a physician can understand the true value of this for me as a writer". Did it also, together with his disease, contribute to the resigned attitude which he shared with a whole series of indecisive or irresolute doctors in his fiction? "With me, a physician, there are few illusions. Of course, I'm sorry for this—it somehow desiccates life." His conception is reflected in the epoch-making plays where he abandoned the traditional dramatic conflicts—replacing them with a tender observation of emotional life; "solving problems is not the artist's mission—his only one is to be an impartial witness." Initially not everybody was impressed; his good friend, Leo Tolstoy muttered "Where is the plot? The action keeps stamping on the same spot."

Chekhov developed his tuberculosis at an early age. As sometimes is the case with doctors, he stubbornly refused to accept his colleagues' diagnosis and carefully hid the telltale specks of blood on his handkerchief from the anxious eyes of his parents. Nevertheless, the secret preoccupation with his condition finds expression in many of his works[25], imbued with nostalgia and a melancholic foreboding of death, as in the closing lines of *The Black Monk:*

"Blood began to flow from his throat straight on to his breast.—He fell to the floor and called: 'Tania!' He called to Tania, he called to the great gardens with their lovely flowers sprinkled with dew, he called to the park, to the pines with their rugged roots, to the fields of rye, to his wonderful science, to his youth, courage, joy, he called to life that was so beautiful. He saw on the floor, close to his face, a large pool of blood, and from weakness he could not utter another word, but an inexpressible, a boundless happiness filled his whole being."

Doctor Chekhov well knew and cherished the pre-terminal euphoria which makes our last departure easier by spreading a merciful veil over painful reality. Shostakovitch, who had spent long periods in a sanatorium, must have had a kindred feeling for his fellow-sufferer when he cited *The Black Monk* as the key to his Fifteenth Symphony, having given death-agony as the key to the Fourteenth.

In the spirit of Chekhov, the consumptive author Katherine Mansfield wrote melancholy stories while she was slowly dying, "There is a little boat, far out, moving along, *inevitable* it looks and *dead silent*—a little black spot, like the spot on a lung". Like many creators before her, suffering from mortal disease, she was distressed to leave this world where there still was so much to delight in:

At night, in the wide bed
With the leaves and flowers
Gently weaving in the darkness,
She is like a wounded bird at rest on a pool.
Timidly, timidly she lifts her head from her wing
In the sky there are two stars
Floating, shining . . .
O waters—do not cover me!
I would look long and long at those beautiful stars!

O my wings—lift me—lift me!
I am not so dreadfully hurt ...

No, not yet; for a few more years she led an adventurous
sexual life, exulting, "we made love like two wild beasts".
Progressive tuberculosis eventually calmed her down. She
related her female experiences to her friend, D. H. Law-
rence, supplying material for some of the famous erotic
descriptions which he could hardly have invented. Was
aversion to the disease they had in common, and the
sequels with sexual weakness, the reason he sometime
told her she was revolting "stewing in your consump-
tion"?

Like Chekhov, Lawrence also tried to the very last to
conceal his tuberculosis, from himself as well as from
others, by giving it different names—flu, bronchitis,
common cold. He transformed it into fiction by passing it
on to Lady Chatterley's lover, the gamekeeper who was
"curiously full of vitality, but a little frail and quenched"
—not to the degree, however, that it prevented him from
sharing the most violent ecstasies with the lady,
herself ill and feeble from boredom and sexual starvation.
The frank and detailed descriptions of their passion,
trembling with excitement, shocked his contemporaries.

This new literary realism was coloured, even prompted,
by Lawrence's illness. The novel was written during the
last stages of tuberculosis, when the toxins, circulating in
his blood, made him weak and weary. Did his latent
homosexual tendency facilitate his understanding of
female sexuality?[64] Be that as it may, it is through Lady
Chatterley that he expresses his lassitude—"Why don't I
really care?"—and his fear of approaching death, of the
"ghastly white tombstones—detestable as false teeth
—which stick up on the hillside".

The disease also hampered Lawrence's own sexual
activity; in fact, he became impotent. As so often occurs,

63. A. Beardsley, "As the dawn broke, Pierrot fell into his last sleep. Then upon tip-toe, silently up the stairs, came the comedians Arlecchino, Pantaleone, il Dottore and Columbina who with much love carried away upon their shoulders the white frocked clown of Bergamo, whither we know not."

the unsatisfied desire nourished erotic fantasies which in their feverish intensity resemble the dreams of puberty in which there is no end to the flowers, threaded in the pubic hair, "forget-me-not flowers in the fine brown fleece of the mound of Venus" and "a bit of creeping-jenny round his penis", to mention only a few assorted localities.

All this gives *Lady Chatterley's Lover* the character of a consumptive novel. It has traits in common with the works of Aubrey Beardsley, who also manifested a restrained sexuality but in a more sophisticated form. With intricate artistry, this master drawer gave expression to the "fin de siècle" atmosphere and to "art nouveau". Tubercular since his boyhood, Beardsley was greatly affected by his disease and was well aware of his destiny: "yesterday I was laid out like a corpse with a haemorrhage. For me and my lung there seems to be little hope".—"I shall not live longer than did Keats" he said and drew himself lying in bed, dying, while his co-actors on the stage of life assembled to bid farewell (Fig. 63). Still he worked with the intensity of a condemned man—as he literally was.[94]

In his refined, decadent art we find both sexual hunger and defiance. Beardsley was haunted by feverish, erotic fantasies, arising from illness and from sexual repression and concealment. His friend Yeats tells that Beardsley's sexual desire under the pressure of disease had become insatiable and he admits this with a portrait of himself tied to Priapus (Fig. 64). Beardsley implies an illness-related impotence. He tries to satisfy his desire instead, and vindicates himself by making indecent drawings. With progressing disease and weakness his art became increasingly obscene—but it also reached new heights of elegance, artistry and skill. The last sheets, illustrating *Lysistrata*, drawn between haemorrhages from the lung, defied publication for a long time, unfortunately, as there rarely has

64. A. Beardsley, The artist tied to Priapus, symbol of sexuality.

LYSISTRATA.

65. A. Beardsley, Lysistrata, shield-
ing her cointe while the penis is as
adoringly decorated as that of Lady
Chatterley's lover.

been created more charming and loveable, innocently
candid, erotic art (Fig. 65).

A more playful but equally defensive attitude towards
the disease was taken by the German poet Christian
Morgenstern at the turn of the century. He caught tuber-

culosis from his mother and spent his short life in and out
of sanatoria. He faced his illness and asserted his inner
freedom with sick humor. In the spirit of François Villon
he made fun of his tragic fate in grotesque *Gallows
Songs.*[57] He observed that "From the gallow hill you see
the world differently and you see different things than
others do." We find them in his *Gallows Brother's Spring
Song:*

Spring, even on *our* splinter, springs;	Es lenzet auch auf unserm Spahn,
O sing for the blissful days!	o selige Epoche!
Here, now, in the breeze there swings,	Ein Hälmlein will zum Lichte nahn
Now, over there, there sways	aus einem Astwurmloche.
A young stem yearning toward the light	Es schaukelt bald im Winde hin
Out of a woodworm's bore.	und schaukelt bald drin her.
I feel almost as if I might	Mir ist beinah, ich wäre wer,
Be what I am no more.	der ich doch nicht mehr bin ...

66. I. Arosenius, St. George and
the dragon—the artist fighting his
hemophilia, the bleeding disease
which finally killed him.

Miscellaneous physical illnesses

The Swedish painter of fairy-tales, Ivar Arosenius, died from *hemophilia*, the bleeding disease, when he was only thirty. This hereditary complaint had already claimed his elder brother, who at fourteen bled to death after having a tooth extracted. Arosenius was deeply conscious of the constant danger that hung over him and he depicted it with bloody realism. Never has a dragon bled so convincingly and profusely as the one which encountered the artist in the shape of Saint George (Fig. 66), fighting the disease. The haemorrhages were accompanied by much pain and restricted his movements; the slightest blow or bruise produced nasty effusions and painful swelling of the joints. These circumstances had a fundamental effect on his artistic work—both of a conducive and a modifying nature. During the long periods when, as a child, he had to stay in bed, he amused himself by drawing and painting. He thus acquired a fantastic manual dexterity; few other artists have found it so easy to transfer their ideas to paper. Not only the form but also the content of his art was affected by the disease. From the outset it manifested itself mainly as a desperate revolt, a wild desire to forget his condition and to extract from life what it had to offer as quickly and as intensely as possible. He paints himself weak and exhausted, riding his pegasus to seek oblivion with the girl and the bottle (Fig. 67).

Arosenius was rescued from the wear and tear of his bohemian life through a blissful marriage, which yielded him some years of unalloyed happiness. His greatest joy is his little daughter, for whom he paints some of the most

beautiful, imaginative, and eloquent fairy-tale illustrations to be found anywhere—for instance, that of the poor beggar-boy who does not join in the general hurry and scurry, and yet—or perhaps, just for that reason —finds the golden goose and accordingly gains the princess's hand and half the kingdom.

Arosenius's happiness was not unclouded, for the dangerous disease still lurked. Having once nearly died from a nosebleed, he worked with tremendous intensity, knowing that his days were numbered. At the jolliest feast Death suddenly takes a seat as an unbidden, fearsome guest, *A Macabre Company* (Fig. 69). Death was indeed near, and not only in Arosenius's imagination. One evening, while his wife was sleeping, he sat working, even though he had a sore throat. Suddenly she awakened to find her husband choking. Before help could be called he was dead—from bleeding in the throat—and a life, beautiful but all too brief, had ended.

One of the most original artists of our time was Paul Klee. Highly talented and musical, he found new modes of expression for art which transmitted the spontaneous joy of the hand and mind in forming new pictures in new

67. I. Arosenius, *The weak and exhausted artist on his Pegasus, consoled by girl and bottle.*

68. I. Arosenius, *Boy returning the golden goose requests his reward. Notice how the princess shyly peeks.*

colours; intricate, previously unconceived constellations. He loved "to go for a walk with a line". His imagination was original and exuberantly rich. We see how much fun he must have had in constructing the peculiar and fantastic piece of architecture, which he calls *Sängerhalle* ("Hall of the singers") (Fig. 70). It must have been a happy artist who wielded the pen and brush in this picture and hoisted the flag on the turret!

The bliss did not last long, however; when only forty, Klee began to suffer from *scleroderma*, a most serious disease that involves shrinkage of the skin and underlying muscles. It is still incurable and usually leads to death in a matter of four or five years. It progresses inexorably and is also penetrative. Tragically, this progression is obvious to the patient; almost day by day he can see death approaching. Most of us are already undergoing, or will soon develop, the pathological changes that ultimately terminate life, but fortunately they are concealed from us;

69. *I. Arosenius, Death is macabre company at the jolliest feast, with the Swedish poet Bellman's words:*
Empty your glass for Death awaits you,
Pluck your guitar
Tune your strings and sing of the springtime of Life.

we cannot see our own degenerative process. This helps
to conceal the briefness of life. But the complaint which
destroyed Klee could not be concealed and it was not long
before he found that it affected not only his mind but his
art. He experienced difficulty in executing detailed pic-
tures because of the rigidity of his joints. He illustrates his
condition in a drawing of a sad figure, *Ein Gestalter*
(a creator) holding a pen in his crippled hand (Fig. 43)
—a situation similar to that of Renoir (Fig. 42) and Dufy
with their arthritic joints—but Klee's was hopeless.

His work now loses its gay, exhilarated character and
thoughts of death and transformation are his constant
companions—almost the only ones as he experienced the
loneliness of most of us when approaching death and
lived his last years in utter spiritual solitude;[31] "one dies
alone", said Pascal. He expressed his agony only through
his work, "never have I drawn so much, nor so intensely"
and he confessed: "I create—in order not to cry." His

*70. P. Klee, Hall of the
singers. The artist was
happy "to go for a walk
with a line".*

late drawings form a funereal suite of rare vehemence with titles like *will dabei sein* (prefers to remain) and *trennt sich schwer* (departs reluctantly). One of the last, *durchhalten!* (endure!) (Fig. 71 a) is a moving expression of the artist's effort to keep up his courage in view of life's tragedy and to follow Montaigne's advice: "endure, suffer and keep quiet". The drawn lines around the mouth resemble the artist's own sad, strained features, marked by disease (Fig. 71 b). It was not long before *The Sick One in the Boat* had Charon as oarsman (Fig. 72).

A Swedish poet was similarly afflicted with a horrible disease, *progressive myasthenia* or muscular debility, which causes increasing paralysis; this was Hjalmar Gullberg, whose harrowing words show that extreme human misery, caused by severe bodily illness which can hardly

71 a. P. Klee, *Durchhalten!—endure!—*resembles the artist, marked with the traits of his disease.

71 b. P. Klee, Photo.

be tolerated, may still be expressed in beautiful and moving verse. In the form of a poem he replies to a young man who complained to him about the mental distress which arose from his own creative endeavours:

But I am old
and many are the letters of this kind
that I have read.
I am passing through a crisis.
Maltreated flesh is real in a way
different from a soul in distress.
Proof of this I found
in the stinking pus that flowed.
Now I am reached by a fragrance of the bird-cherry.
You are a young man in good health.

In his late poetry there are reflections of Gullberg's serious disease, noticeable also in his handwriting (Fig. 73). He expresses a longing for annihilation:

72. *P. Klee, Ill in boat—soon with Charon as oarsman.*

Deeper within, through bone and marrow,
days and nights throughout,
one wish only, only one—
others have so many,

and reveals a shocking and pathetic knowledge of the
lamentable final decomposition of our physical being. His
mouthpiece is the man "who found Ophelia, dead in the
mire":

I found Ophelia. She rose to the surface in the reeds,
her hair undone. She was much changed . . .
Death through pouring water
is what I found in my nets: A swollen
mermaid put to fermentation by the brook.
What did I do first when I found, in all her finery,
a court lady in the wet mire?
I saw what I saw. Then I vomited in the reeds.

When Gullberg was threatened with a worsening of his
disease—another flow of stinking pus—he chose to
follow Ophelia into the wet mire.
 Rainer Maria Rilke displayed the same heroic forbear-
ance in the face of the *leukemia* which took his life after

73. *Dead in the mire. Facsimile. The
shaky corrections in his formerly neat
hand and the tragically drastic sub-
ject testify to Hjalmar Gullberg's
progressive infirmity.*

many years of suffering, and he is said to have refused analgesics so as not to quench his creative power. After having completed a draft of the first two *Duino Elegies* he was poetically mute for a number of years and must have wondered whether he would ever complete them. But then, in a sudden flash of inspiration he completed "everything in the course of just a few days; it was an indescribable storm, a hurricane in my soul".

Besides the ten elegies, he also penned the ecstatic meditations on poetry and death, never far away, in *Sonnets to Orpheus*[70]:

Sei – und wisse zugleich des Nicht-Seins Bedingung,
den unendlichen Grund deiner innigen Schwingung,
dass du sie völlig vollziehst dieses einzige Mal.

Be—and yet know the great void where all things
 begin,
The infinite source of your own most intense vibration,
So that, this once, you may give it your perfect assent.

A sublime sigh, consoling through its compassion.
Soon afterwards the first signs of his disease presented themselves:

Come thou, the last one whom I own,
The horrid pain in my malignant blood!

Rilke loved flowers and found the height of rapture in the rose—he was finally rapt away by a thorn prick at a time when disease had deprived him of all defense against infection and death. As a modest return, a rose was named after him. This is the romantic version of a poet's end—the prosaic cause of death was not blood-poisoning, but acute leukemia.

The remarkable conjunction of disease and creativity

has invited conjectures about a causal connection. According to one imaginative theory, the excess of creativity brought on the disease psychosomatically: "All that is left in me of fibre and stamina was strained to breaking point." The opposite has also been suggested, namely that the disease was transformed into creativity, as Novalis (see p. 22) once surmised. From a medical point of view, however, the most probable link, if any, is that the poet, consciously or unconsciously, felt the disease coming on and, with a presentiment of death, hurried to fulfill his mission, to complete his "own most intense vibration" before it was too late. This possibility is supported by Rilke himself: "But now it's *done*. Done. Done. *Amen*. So this is what I survived for, through everything. Through all of it. And that, after all, was what I needed. *Only* this."

Béla Bartók, who died with the same kind of "malignant blood", complained that he had "to go with so much still to say". Progressively emaciated and excited by continuous fever, he composed his swan-song, the third piano concerto. In the shadow of death and pitifully exiled, he recalls the riches and possibilities of life in tunes which have their sources in the folk songs from the land of his fathers.

A female counterpart is the fatally ill but strongminded Flannery O'Connor,[65] who fought a natural self-pity with grim humour and looked evil straight in the eye, in her life as well as in fiction, where "a good man is hard to find" and a nice girl is apt to get fooled, especially if she is lame. Her disease, *lupus erythematosus*, cripples by affecting the joints, but later attacks one organ after another. "My father had it—but at that time there was nothing for it but the undertaker; now it can be controlled with the ACTH"—and this gave her another invaluable fifteen years to live and work. In the English term, "butterfly rash", there is the same lighthearted, deceptive way of

expressing a sinister reality that we find in her writing. "I have never been anywhere but sick. In a sense, sickness is a place, more instructive than a long trip to Europe, and it is always a place where there's no company, where nobody can follow. Sickness before death is a very appropriate thing and I think those who don't have it miss one of God's mercies." Her unconditional assent to disease is reminiscent of Pascal's pious submissiveness (p.20).

She even played on the word *lupus*, Latin for wolf, when the illness finally got the better of her: "the wolf, I am afraid, is inside, tearing up the place"—and she faltered with anemia and kidney insufficiency. "I had a blood transfusion Tuesday, so I am feeling sommut better and for the last two days I have worked one hour each day and my my I do like to work. I et up that one hour like it was filet mignon." In this misery she found that "what you have to measure out, you come to observe closer, or so I tell myself". Her close observations are related in a mature, uniquely personal style in her last stories, completed when she was dying. Her strong religious belief may have combined with the continuous threat of a fatal disease to engender her fascination with unrelenting fate as well as with merciless characters and doomed individuals.

At the end of our dance of death with poets, painters and composers, we will let Flannery O'Connor join hands with Juan Gris and Gustav Mahler.

Juan Gris was the third of the great cubists, somewhat younger than Picasso and Braque. He was their friend and comrade, as well as their equal in artistic creativeness, becoming perhaps the most discerning. He often used a more vibrant colour scale than Picasso and Braque, especially in the early days of cubism, when these two artists excelled in subtle harmonies of greys and browns. Juan Gris was much taken by this new possibility of deriving new values from reality, by viewing a subject from several

74. J. Gris, Cubistic painting by the healthy artist.

angles at once, as Cézanne had done, and unfolding it so as to produce intricate patterns, with overlapping angles and triangles (Fig. 74).

By nature Juan Gris was melancholic and withdrawn. During a period in the late twenties he felt his work had become somewhat cold, a little too intellectual and, like others before him, he cherished an ambition to reach beyond himself. He wished to convey more human life and warmth, but to this end he violated his individuality,

and all are agreed that his work lost in artistic power and intensity. The paintings seem a little inflated, the colours drier and the high artistic merit of his earlier work is clearly absent. At this time Juan Gris had the first symptoms of a disease which in the course of a few years was to terminate his life. He had had scarlet fever and ultimately died from chronic renal failure. The diagnosis of uremia was not made at once; he had increasingly severe attacks of asthma which were erroneously considered to be allergic and for which injections, sedatives and a change of climate were prescribed. He found it difficult to work for long periods at a time and complained that some of his pictures took on a sickish tone. Still he continued to paint with great willpower. His last pictures show that his illness had induced him to abandon all ambitions to get outside himself—here he again gives full expression to his own strong personality and recovers his original greatness (Fig. 75).

75. J. Gris, Painted while the artist was dying from uremia but recovering his original artistic strength.

Contemplating these last heroic efforts of Gris, Gustav Mahler's immensely beautiful and sad chords of *Das Lied von der Erde* ring in the background. The inevitability of death and the hope of resurrection had been a constant theme in this composer's art ever since a slight heart murmur had been discovered (see p. 56). When the ominous streptococci settled on his heart valves after a throat infection, the disease took a fatal turn. Aware that death was imminent, Mahler composed in a more solemn and serene vein, a definite farewell to life.

He writes to Bruno Walter[53]: "You do not know what is going on within me; but it is certainly not the hypochondriac fear of death that you surmise. That I shall have to die, I had already realized ... But without trying to explain or describe something for which there are perhaps no words at all, I'll just tell you that at one blow I have simply lost all that I ever attained of clarity and equanimity; that I stood face-to-face with nothingness and now, at the end of life, am again a beginner who must find his feet." Theodor Reik,[60] the psychoanalyst, discusses Mahler's attitude: "One can trace through his letters, through certain things he said, but most of all through his music how his reaction to the near end was changing, how he himself changed, how he discarded everything that was alien to him. When he confronts perdition naked, there is no more sentimentality, no false emotionality, no false tones. Here a man rises highest at the moment he is crushed ... There, where others sink, he soars to an unsurpassable height."

Epilogue

The song is born of sorrow
But out of song is gladness bred[82]

A salient feature of an artist's work has at times been ascribed erroneously to a disease, as when the elongated figures of El Greco were thought to be due to astigmatism, a visual defect. The numerous examples in the foregoing pages have shown, however, that illness has, indeed, often deeply influenced not only the life but also the work of great authors, artists and composers. Hans Christian Andersen of fairy-tale fame is emphatic about the power of pain and its prominent place in the history of culture. His *Aunt Toothache* argues merciless *ad hominem*: "So you are a writer' she said, 'well I will write you up in all the poetic measures of pain!' It was as if I had got a glowing awl into the cheekbone! 'Do you admit now that I am mightier than Poetry, Philosophy, Mathematics and all of Music? Mightier than all these sensations depicted in Painting and Sculpture?—and older also. I was born close to the garden of Eden, outside, where the wind blew and the wet fungi grew. I made Eve dress in the cold, and Adam, too. There was force in the first tooth-ache, believe me." A raging attack suffices to convince the victim that suffering and pain make a big difference (see Shaw and Updike, p. 19). Many authors, artists and composers have themselves been well aware of the important role that their disease has played, as seen in the quotations from Byron (p. 83), Proust (p. 58), van Gogh (p. 76) and Schumann (p. 79).

 This of course does not imply that suffering is a prerequisite for artistic creation, nor that a creator has to be ill in order to make suffering real to us. Thomas Mann goes

through both tuberculosis and syphilis—but only in his fiction[92]. Hieronimus Bosch paints gruesome pictures of terrible pain that he never experienced himself, and Johan Sebastian Bach, though hale and hearty, enables us, through vehement cadences, imitating the lashes of the scourge, to attend the summit of suffering, the flagellation of Christ.

While the effects of a particular disease do tend to be similar, exceptions occur as a result of differences in the personal traits of the victims; examples are the very different reactions to gallstone disease in Scott and Tegnér, to tuberculosis in the Bronté sisters and to physical malformations in Byron and Toulouse-Lautrec.

Disease can influence creativity in many ways. It is beyond dispute when it is the main reason why the artist dedicated himself to artistic creation, as when Pierre de Ronsard became a poet when deafness blocked a diplomatic career, when Matisse started painting when appendicitis interrupted a legal career, or when Vivaldi took up composing because asthma prevented him from conducting Mass.

When it comes to the direct influence of disease on the work, even the technical execution may be affected. This is apparent in the late paintings of the half-blind Monet. We learn from them that disease occasionally may influence the direction of art's development, independently of the creator's own intentions. With the confused design and strange colours in these works, Monet unawares took a step from our reality and thus inspired the transition towards abstract art. "L'art brut", insane art, has left traces in the development and Hoelderlin's schizophrenia gave new impulses to poetry, providing hitherto unknown modes of expression. Paganini, on the other hand, benefitted from a congenital defect, an abnormal laxity of the fingerjoints which enabled, even tempted him, to play and compose virtuoso pieces for the violin.

The experience of disease has provided some authors, like Molière and Proust, with medical metaphors and has given others material for descriptions of disease, as we see in Charlotte Bronté, Chekhov, Dostoevsky, Virginia Woolf and Goya. It must be more of a challenge to represent suffering in musical terms; still Marain Marais goes through a complete operation in a composition and Beethoven and Smetana both let us actually hear the unpleasant sounds in their diseased ears.

Disease may even act as an inducement. The degrading effect of physical deformities caused Byron and Toulouse-Lautrec to compensate through artistic work. The definite knowledge that the remaining working hours are limited has often given rise to a last blaze of intense activity, in Beardsley and Klee, for instance. Many, with Heine, Karen Blixen and Graham Greene have ascribed a therapeutic effect to creativity, a means of enduring the suffering of life. In *The Birth of Tragedy* Nietzsche says that it is only Art that has the power of diverting our feelings of disgust for a dreadful and meaningless existence into conceptions that one can live with. Flaubert was of the same opinion, "The only way of leading an acceptable life is to drown oneself in literature as in an endless orgy."

Samuel Johnson asserted that he did not know a single day entirely free from pain since a childhood disease had left him forever a bundle of tics and tremors. They were so conspicuous that he had to abandon plans to become a school director[59]—his peculiar behaviour and grotesque movements made his merciless pupils roar with laughter. He concluded that "the only end of writing is to enable readers better to enjoy life or better to endure it". The Doctor himself, victim of severe periodic depression, was helped by his writing, "Employment, Sir, and hardships, prevent melancholy."

Finally, the most important and impressive influence of disease on artistic work is when it makes the whole character more serene, the keynote more profound. This, I think, has added to the lasting value of the fiction of Charlotte Brontë and Chekhov, the poetry of Keats, the late paintings of Cézanne and Rothko and the music of Chopin and Mahler.

* * *

Realizing that some of the greatest art has been born of suffering, one is led to conclude that illness sometimes enriches the artist, his fellow men and posterity: "The suffering inspires the poet, imparts greatness, sincerity and earnestness to his vision, stimulates his psychological imagination and gives pithy realism to his expressions of wrath and passion."[11]

One reaction is consistently present in the majority of artists, whatever their illness, namely a remarkable stoicism, even heroism, when confronted with this sort of ill fate. The urge and endeavour to achieve an original creation, to immortalize a personal conception, may overcome even extreme morbidity. In great artists, the passion to create generates a willpower strong enough to defeat the worst disease.

This tale of woe shall end in a lighter key with divine
music celebrating a happy cure, as described on page 125.

*In the beginning of the eighteenth century, Marin Marais composed a
piece for viola da gamba describing the steps of an operation for stone in
the bladder and the feelings of the patient. They are inscribed in the
score, e.g. "The view of the operating table—trembling at the sight of
it—serious thoughts—the incision—here the stone is delivered—here
one nearly loses one's breath—blood is flowing—here one is put back
to bed."*

*The relief is evident—after the ordeal of having had his bladder
stone removed, the composer expresses his feelings in no less than three
gay dances, entitled Les Relevailles, "churching of a woman after
childbirth!"—the happiest, indeed, of all human pain.*

Illustrations

35. D. Maclise, Paganini performing. Drawing, 1831. Courtesy, Bettmann arch. N.Y.C.
36. R. Strauss, Im Abendrot. Facsimile. Courtesy R. Strauss Sammlung, Garmisch.
37. E. Delacroix, Jacob fighting with the angel. Oil. St. Sulpice, Paris.
38. P. Cézanne, Les grosses pommes. Oil, 1890. Priv. coll.
39. P. Cézanne, Pyramide de cranes. Oil, 1900.
40. P. Picasso, L'artiste et son modèle. Engraving, 1927. © SPADEM, Paris 1982.
41. P. Picasso, L'artiste et son modèle. Engraving, 1968. © SPADEM, Paris 1982.
42. A. Renoir, Self-portrait. Drawing.
43. P. Klee, Detaillierte Passion: Ein Gestalter. Drawing, 1940. © Cosmopress, Genève 1982.
44a. R. Dufy, Flowers and handwriting while ill with rheumatism. Watercolour.
44b. R. Dufy, Flowers and handwriting when improved. Watercolour. Reprinted by permission of The New England Journal of Medicine.
45. Cl. Monet, Le Bassin aux Nymphéas. Oil, 1900. The Art Institute of Chicago.
Le Pont Japonais à Giverny. Oil, c. 1923. The Minneapolis Institute of Arts. © SPADEM, Paris 1984.
Le Pont Japonais. Oil, c. 1923?
Musée Marmottan, Paris. © SPADEM, Paris 1986.
46. El Greco, Burial of the Conde de Orgaz. Oil, 1586. Santo Tomé, Toledo.
47. E. Dickinson, Portrait. Daguerreotype. Amherst College. Reproduced by permission of the Trustees of Amherst College.
A. Dürer, Self-portrait. Drawing, 1491. Erlangen, Universitätsbibliothek.
48. F. Goya, Allegory on the adoption of the constitution. Oil, 1812. Nationalmuseum, Stockholm.

49. F. Goya, Saturn. Oil, 1820–23. Museo del Prado, Madrid.
50. J. P. Lyser, Beethoven. Drawing, 1823.
51. Lacocoon, Greece; 1st century B. C. The Vatican.
52. P. Picasso, Study for Guernica, pencil, Courtesy Nationalmuseum, Stockholm.
53. A. Böcklin, Toothache. Stone-relief, 1870. Kunsthalle, Basel.
54. F. Picabia, Paroxysme de la douleur. Oil, 1915, Coll. Simone Collinet. © SPADEM, Paris 1982. © A.D.A.G.P., Paris and Cosmopress, Genève.
55. H. Matisse, L'angoisse s'amasse. Linoleum-cut, 1940.
56. A. Watteau, The Medical Faculty. Engraving.
57. Anonymous. Operation for stone in the bladder. Engraving.
58. F. Goya, Donkey as doctor. Engraving.
59. F. Goya, Self-portrait with Dr Arrieta. Oil, 1820. Minneapolis Institute of Arts.
60. A. Watteau, La leçon d'amour. Oil, c. 1716–1717. Nationalmuseum, Stockholm.
61. Ch. Brontë, Portrait of Anne Brontë. Drawing. The Brontë Society.
62. H. Löwenhjelm, Death approaching. Wood-cut, 1919.
63. A. Beardsley, Pierrot dying. Drawing, 1897.
64. A. Beardsley, The artist tied to Priapus. Drawing.
65. A. Beardsley, Lysistrata. Drawing, 1896.
66. I. Arosenius, St. George and the dragon. Water-colour, 1903. Priv. coll.
67. I Arosenius, Self-portrait on Pegasus. Watercolour.
68. I Arosenius, Boy returning the golden goose. Water-colour, 1908. Priv. coll.
69. I Arosenius, Macabre Company. Watercolour, 1908. Priv. coll.
70. P. Klee, Sängerhalle. India ink and watercolour, 1930. Priv. coll. © Cosmopress, Genève 1982.

71a. P. Klee, Durchhalten! Drawing, 1940. Paul Klee-
Stiftung, Bern. © Cosmopress, Genève 1982.

71b. P. Klee, Photo.

72. P. Klee, Kranker im Boot. Drawing, 1940. Paul Klee-
Stiftung, Bern. © Cosmopress, Genève 1982.

73. Hj. Gullberg, Poem with corrections. Facsimile.
Lund University.

74. J. Gris, Nature morte au géranium. Oil, 1915.
Priv. coll.

75. J. Gris, Nature morte avec pipe. Oil, 1926. Priv. coll.

Finale. M. Marais, Le Tableau de l'Opération de la Taille,
and Les Relevailles. Facsimile. Pieces de Violes, Livre V,
1712. Bibliothèque Municipale, Lyon.

Bibliography

1. Alpers, Antony, *The Life of Katherine Mansfield.* London 1980
2. Aragon, *Henri Matisse, Roman.* Paris 1971
3. Arnavon, Jacques, *Le Malade imaginaire de Molière.* Genève 1970
4. Bader and Navratil, *Zwischen Wahn und Wirkligkeit:* Kunst, Psychose, Kreativität. Lucerne 1976
5. Barzun, Jacques, Clio and the Doctors. Chicago 1974
6. Berefelt, Gunnar, *Notiser om psykopatologiskt bild-skapande.* Forskning och praktik 7 (1972), p. 73
7. Berlioz, Hector, *The Memoirs of Hector Berlioz.* New York 1969
8. Bishop, Morris, *Ronsard, Prince of Poets.* London 1940
9. Björck, Staffan, *Sångaren och plågan.* Birger Sjöbergssällskapet 1966, p. 34
10. Blomberg, Erik, *Hoelderlin.* Stockholm 1960
11. Böök, Fredrik, *Esaias Tegnér.* Stockholm 1946
12. Bordonove, G., *Molière génial et familier.* Paris 1967
13. Brittain, Robert, *Poems by Christofer Smart.* Princeton 1950
14. Butor, Michel, *Le Carré et son habitant.* Nouvelle revue Française 1961
15. Carstairs, G. M., *Art and psychotic illness.* Abbottempo
16. Cawthorne, F., *The influence of deafness on the crea-tive instinct.* The Laryngoscope 70 (1969), p. 1110
17. Christy N. P. et al., *Gustav Mahler and his illnesses.* Trans. Am. Clin. and Climatol. Ass. 82 (1970), p. 200

18. Clark, Kenneth, *Civilization*. London 1969
19. Conrad, Joseph, *Letter to John Galsworthy*, 1908
20. Copleston, F., *Friedrich Nietzsche, philosopher of culture*. New York 1975
21. Dickinson, Emily, *The complete poems of Emily Dickinson*. London 1979
22. l'Echevin, Patrick, *Musique et médecine*. Diss. Lille 1980
23. Edel, Leon, *Writing Lives*, New York 1984
24. Von Eichendorff, J. *Im Abendrot*, translated by Michael Hamburger
25. Epstein, Joseph, *Partial Payments*. New York 1989
26. Ferrari-Barassi, Elena, *Gesualdo* in Honegger, M., Dictionnaire de la Musique. Bordas 1970
27. Focillon, Henri, *Piranesi*. Paris 1928
28. Franken, F. H., *Krankheit und Tod grosser Komponisten*. Baden-Baden 1979
29. Gastaut, Henri, *Génie et épilepsie*. Hexagone Roche 1985
30. Gautiers, Théophile, *Voyage en Espagne*. 1834
31. Glaesemer, J., *Paul Klee, Handzeichnungen* III. Bern 1979
32. Hamburger, Michael, *Friedrich Hoelderlin*. Cambridge
33. Haschek, H., *Musik und Medizin*. Wiener Med. Wchschr. 1, 128 1978
34 Heller, K., *Michel de Montaignes Einfluss auf die Aerztestücke Molières*. Diss. Jena 1908
35 Henson, R. A. and Ulrich, H., *Schumann's hand injury*. Br. Med. J. 1978
36 Herrera, H., *Frida*. Harper & Row. New York 1983
37 Hesseltyne, Philip, in Gray, C. and Hesseltyne, Ph., *Don Carlo Gesuando, Prince of Ventosa*. London 1926
38. Homburger, F. and Bonner, D. D., *The treatment of Raoul Dufy's Arthritis*. New England Journ. of Med. 301 (1979), p. 669

39. Huxley, Aldous, *The Doors of Perception*, 1954
40. Jack, D., *Matisse on art*. London 1973
41. Jerphagnon, L., *Pascal et la Souffrance*. Les éditions ouvrières, Paris 1956
42. Kern, Ernst, *Zur Kulturgeschichte des Schmerzerlebnisses*. Hefte z. Unfallheilkunde 138 (1979), p. 9
43. Keller, Karl, *The only Kangaroo among the Beauty. Emily Dickinson and America*. Baltimore 1979
44. Kerner, Dieter, *Krankheiten grosser Musiker*. Stuttgart 1980
45. Kierkegaard, Søren, *Enten—eller*. København 1843
46. Kilmer, Nicholas, *Poems of Pierre de Ronsard*. Univ. Calif 1979
47. Kretschmer, Ernst, *Geniale Menschen*. Berlin 1929
48. Laing, Joyce H., *Tuberculous paintings*. Ciba Symposium 12 (1964), p. 135
49. Lisle, Laurie, *Portrait of an Artist*. A Biography of Georgia O'Keefe 1986
50. Low, Marie DuMont, *Self in triplicate: the doctor in the nineteenth-century British novel*. University of Washington. 1973
51 Lundström, L.-J., *De artificiella paradisen*. Hässle 2 (1964), p. 5
52. ibid., *Charles Méryon, peintre-graveur schizophrène*. Acta Psychiatr. Scand. 40 (1964), p. 159
53. Mahler, Alma, *Gustav Mahler: Memoirs and Letters*. New York 1946
54. Malmberg, Bertil, *Idealet och Livet*. Stockholm 1951
55. Matisse, Henri, *Propos recueillis par Régine Pernoud*. Le Courrier de l'UNESCO 1953, p. 6
56. Mondrian, Piet, *Plastic and pure plastic art*. London 1937
57. Morgenstern, Christian, *Gallow's Songs*. Translated by W. D. Snodgrass and Lore Segal. Univ. of Michigan Press, Ann Arbor 1967
58. Murray, Shannon and Murray, T. J., *The Epilepsy of Dostoevsky*. Nov. Scot. Med. Bull. 1980

59. Murray, T. J., *Dr Samuel Jonson's movement disorder.* N.Y. State J. Med., 1979
60. Niederland, William G., *Psychoanalytic approaches to artistic creativity.* New York Acad. of Med. 1975
61. Ibid., *Goya's Illness.* N.Y. State J. Med. 1972
62. Nordenfalk, Carl, *The Stockholm Watteaus.* Nationalmuseum Bulletin 3 (1979), p. 105
63. Nordström, Folke, *Goya, Saturn and Melancholy.* Stockholm 1962
64. Ober, William B., *Boswell's clap and other essays.* Carbondale, Ill., 1979
65. O'Connor, Flannery, *The habit of being.* New York 1979
66. Pearson, Hesketh, *Walter Scott.* London 1954
67. Pedersen, L., M. and Permin, H. *Rheumatic Disease, Heavy-Metal Pigments, and the Great Masters.* Lancet, 1988
68. Pickering, George W., *Creative malady.* London 1974
69. Ravin, James et al., *Monet's cataracts* JAMA 253 (1985)
70. Rilke, Rainer Maria, *The Sonnets to Orpheus.* Translated by Stephen Mitchell, New York, 1985
71. Sandblom, Philip, *Esaias Tegnérs kroppsliga ohälsa.* Tegnérstudier, 1951
72. Sayre, Eleanor A., *Goya. A moment in time.* Nationalmuseum Bulletin 3 (1979), p. 28
73. Selzer, Richard, *Mortal Lessons.* New York 1974
74. Shaw, George B., *Prefaces.* London 1934
75. Sieburth, Richard, *Friedrich Hölderlin.* Princeton
76. Sontag, Susan, *Illness as metaphor.* New York 1978
77. Steegmuller, Francis, *The letters of Gustave Flaubert 1830–1857.* Cambridge, Mass. 1979
78. Stevenson, Robert L., *Ordered south.* London 1874
79. Stjernstedt, Marika. Vintergatan. Stockholm 1948
80. Storr, A., *The dynamic of creation.* New York 1972

81. Tegnér, Esaias, *Tegnérs brev.* Utg. av Nils Palmborg, Malmö 1954 (Letter 6 Dec. 1818)
82. Topelius, Zachris, *Sången*, 1843
83. Thévoz, Michel. *Art Brut.* Skira, London 1976
84. Trethowan, W.H., *Music and Mental Disorder.* In Music and the Brain. London 1977
85. Trevor Roper, P. D., *The World through Blunted Sight.* New York, 1970
86 Trilling, Lionel, *Introduction.* The selected letters of John Keats. New York 1951
87 Updike, John, *The City.* The New Yorker, 1982
88 ibid., *At war with my skin.* The New Yorker, 1985
89 Wagner-Martin, Linda W., *Sylvia Plath.* New York 1987
90 Walser, Martin, *The World of Franz Kafka.* Ed by J. P. Stern, New York 1980
91. Wand, Martin, and Sewall, Richard B., *"Eyes be blind, heart be still":* A new perspective on Emily Dickinson's eye problem. The New England Quarterly 52 (1979), p. 40
92. Weigand, Hermann, *The magic mountain. A study of Thomas Mann's novel.* Chapel Hill 1964
93. Weinberg, Steven, *The first three minutes.* London & New York 1977
94. Weintraub, Stanley, *Aubrey Beardsley, Imp of the Perverse.* Penn State Univ. Press 1976
95. ibid., *Medicine and the Biographers Art.* New York, 1980
96. Williams, Roger L., *The Horror of Life.* London 1980
97. Wilson, Edmund, *Philoctetes: the wound and the bow.* Cambridge, Mass. 1929
98. Wordsworth, W, Poems
99. Yourcenar, Marguerite, *Le cerveau noir de Piranèse.* Rome 1962

Index

Postscript

This fifth edition of *Creativity and Disease* the author regards, for the time being, as the definitive one. Sections have been added on Pascal, Hoelderlin, Dostoevsky, Katherine Mansfield, Sylvia Plath, Georgia O'Keefe, "L'art brut—raw vision" and Carlo Gesualdo. I hesitated over the inclusion of Edward Munch's portrait of his sick sister as it is so frequently reproduced—but could not resist, considering it's close relation to the theme and the sad pleasure it imparts.

Some of the changes in the book are due to continued flux in the discussion of diagnoses that must remain uncertain, such as the origins of Goya's and Beethoven's deafness and the rheumatism of Renoir and Dufy.

I have drawn from a great number of sources, accounted for in the bibliography, but I specially want to acknowledge the valuable information I gained when studying the works by E. Kern, for medical aspects, A. Storr, psychological problems, H. Weigand and St. Weintraub, literary questions, and D. Kerner, music. I hardly need to defend the abundance of quotations, which give a distinct and authentic contour to the personalities; I also derive comfort from the thought that as great a master of literary style as Anatole France considered it better to stick to an original sentence, well expressed by somebody else, than to appropriate the idea by pronouncing it with one's own voice.

Translations of the poetry are by:

Richard Sieburth: Hoelderlin's *Mnemosyne* and *Hyperion's song of fate*

Michael Hamburger: Hoelderlin's *As on a Feastday,*
The middle of life, Patmos and *Spring,* also
von Eichendorff's *Sunset Glow*
Snodgrass and Segal: Morgenstern's *Gallow Songs*
Patrick Hort: Poems by Tegnér, Josephson, Gullberg
Stephen Mitchell: Rilke's *Sonnets to Orpheus*
In translating Ronsard I have borrowed from Morris
Bishop and Nicholas Kilmer. I finally fumbled myself
with Heine, Storm and the fragment of Stagnelius' *To
putrefaction,* admitting some inconsistency in the rhythm.

As the origin of this work dates back a quarter of a
century I have naturally had much helpful advice over the
years. Special thanks are due to Professor Ingmar
Bengtsson of Uppsala University, Professor Staffan
Björck of Lund University, Doctor Kaj Johansen of the
University of Washington, Ulrika Sandblom of Halifax
and Doctor Susanna Knott of San Diego. Mr Patrick Hort
of Stockholm gave outstanding linguistic advice. Excel-
lent secretarial help has been provided by Mrs Antoinette
Lucas of Lausanne and by Mrs Kerstin Hedin, Ystad,
Sweden. I also thank Håkan Lindström, who did the lay-
out, and the printer, Bohusläningen, for sparing no effort
to make the book itself a work of art.

Since J. B. Lippincott kindly has taken over the editing
of my book, it is the right moment for me to extend
sincere thanks to my courageous good friend, George
Stickley, the only publisher in the U.S.A. who dared to
accept this diversified essay ten years ago and who, with
his wife Margot, has given the project inestimable
support, ever since.